IMAGES
of America

CHINESE IN
MENDOCINO COUNTY

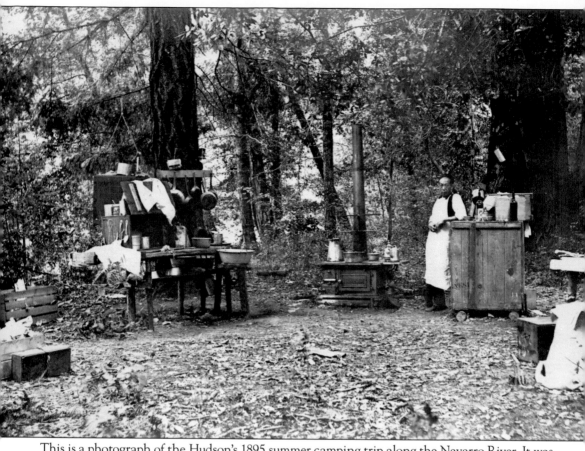

This is a photograph of the Hudson's 1895 summer camping trip along the Navarro River. It was a great time of the year to visit the coastal area to escape the valley heat. The kitchen was set up by Grace Hudson's cook, Soon Quong Wong. (Courtesy Grace Hudson Museum.)

ON THE COVER: This picture shows the Hudson family camping trip to the Navarro River in 1895. (Courtesy Grace Hudson Museum.)

IMAGES
of America

CHINESE IN
MENDOCINO COUNTY

Lorraine Hee-Chorley

ARCADIA
PUBLISHING

Copyright © 2009 by Lorraine Hee-Chorley
ISBN 978-0-7385-5913-1

Published by Arcadia Publishing
Charleston, South Carolina

Printed in the United States of America

Library of Congress Control Number: 2008926279

For all general information contact Arcadia Publishing at:
Telephone 843-853-2070
Fax 843-853-0044
E-mail sales@arcadiapublishing.com
For customer service and orders:
Toll-Free 1-888-313-2665

Visit us on the Internet at www.arcadiapublishing.com

To the first Chinese settlers of Mendocino County and to my parents, George and Martha Hee, who passed on the oral history of the Chinese in Mendocino County to their family and for their strength and defiance of society's rules. Dad, with this book, your promise to your mother "to preserve our history" is still being kept.

CONTENTS

ACKNOWLEDGMENTS

Special thanks to the following: Sylvia Barkley, Gloria Letner-Cooper, Betty Fratis, Grace Hudson Museum (GHM) and staff, Robert Lee, Kelley House Museum, Mendocino County Historical Society (MCHS), Mendocino County Museum (MCM), Fort Bragg Mendocino Coast Historical Society (FBMCHS), Jeff Kan Lee, White Wolf, Loretta Hee McCoard, Katy Tahja, and Ellen Anderson.

INTRODUCTION

Being the great-granddaughter of one of the first Chinese settlers in Mendocino is daunting and yet amazing. Our ancestors endured discrimination and challenges that they probably did not expect when coming to a new country. Reflecting on the oral history passed down by my great-grandfather, Joe Lee, reminds me that my forebears sacrificed a lot for my siblings and me. It is important to acknowledge that this book is a partial fulfillment of a promise that was made to our father about saving and preserving our history and the small red and green building known as the temple of Kwan Tai. Dad, your promise has been kept!

Historically, the Mendocino coast was considered very remote, and it took an individual many days to travel the distance on land or by ship. It was not an easy trip, so the individuals who came had to be very innovative. The first Chinese settlers were of that mind, as they were very industrious and tried to make do with what the land and sea offered.

Using oral history, news articles, and personal letters, this book will document the first Chinese settlers in Mendocino County and explore their legacy through their occupations, the numerous laws specifically directed toward the Chinese, and the history of the Chinese in each small town in the county. This book also contains a history of the Taoist temple of Kwan Tai and the families who remained in the county.

Before beginning this project, I wondered if there were enough pictures to clearly represent the Chinese in Mendocino County, but I was pleasantly surprised to find the following pictures from various collections. These pictures and the Taoist temple are the only physical evidence left that attest to the Chinese presence in Mendocino County.

Currently, due to time constraints and curriculum requirements, our educational systems teach only limited historical information. Mendocino Grammar School, where children are taught local history, including the temple, is an exception. Each Chinese New Year, the school children march in a Children's Chinese Parade in Mendocino ending with a visit to the temple.

While I was growing up in the town of Mendocino, I was taught about the basic history of California, but that history included little to nothing about the diverse cultural groups who were responsible for building California, even though a Taoist temple stood among the historic buildings. Only in recent years has the temple's relationship to the development of the town of Mendocino and the county as a whole been acknowledged in local history. Now a fuller picture of Mendocino County's history is told. We hear the saying "history repeats itself," and one only hopes that we can learn from the past and not let the above saying come to fruition. It is fortunate there were citizens like Grace Hudson and Daisy MacCallum within the county who were strong supporters of the Chinese, or the documents providing us with knowledge of what the first Chinese settlers had to endure would not be available.

One of the things I discovered in my graduate studies was how my grandparents' and parents' lives were impacted by their commerce, occupations, and personal choices.

In doing this research, it was difficult to track some of the original Chinese families because of the different spellings of various names in news articles. For example, my great-grandmother's name is Fong; however, in a 1947 article, it was spelled Tong. The article also had a different name for her husband, but it was easy to link it to my grandmother's first name, Yip, which was never misspelled.

George Hee, my father, did not have an easy life in Mendocino. He had 12 brothers and sisters and would never talk about his dad, Ah Hee. He was afraid we would get into trouble because his dad entered the country illegally. When Ah Hee died in China, our father quit the eighth grade to get a job and help support the family. The family made an agreement with the children that each could take a year off in rotation so that all would graduate from high school. This did not happen, and as a result, George Hee continued to work and was never able to return to school. George never really told his children how hard it was for him to grow up in Mendocino as a Chinese person. However, he really tried to have us assimilate as much as possible and not cause problems in the community. He did state in *Mendocino County Remembered, Volume 1*: "In the early days, we boys and girls had to fight our way. We could handle ourselves and we got by. If you let them run over you, it was just too bad." George worked at various jobs throughout his years. He started as a delivery boy, became a cook at the Albion logging camp, and then went to the sawmill. At 22, he married his first wife, Oneta Martin, daughter of Ed Martin of Mendocino, who was related to the Bishops, a local family, but they were not married long and had no children. Although considered white by the community, it is said that Oneta Martin was also part Native American. At the time of his first marriage in 1919, George Hee owned a poolroom and confectionary shop on the corner of Lansing and Ukiah Streets. He enlarged the store in 1920 to include groceries and to be able to run the poolroom in the evenings. He sold the shop before he divorced his first wife. According to our father, George purchased our grandmother's home but put the title in Yip's name so it would not become part of his divorce settlement. The property was never returned to him but was sold instead to Frank Roberts in the late 1970s. The Hee children were not allowed to purchase the property. George Hee was in his mid-40s when he married our mother, Martha Kellum, in 1941. She was German and Irish American and only 19 years old, and she did not know how old dad was until she signed the marriage certificate.

George and Martha went to Vancouver, British Columbia, to get married because it was illegal in the state of California for any Chinese person to marry a white person. This marriage law was not removed from the books until 1952, and by that time, George and Martha had four children. In 1966, the law was ruled unconstitutional by the federal government. They eventually had 10 children, but only seven survived. They are Raymond Wilfred Hee, Loretta Edith Hee, Dewey Lorin Hee, Lorraine Ann Hee, Wesley Morris Hee, Mervin Wesley Hee, and Wayne George Hee. Unfortunately, Raymond was mentally challenged, and his schooling was limited. In 1949, when he was three months old, Dewey contracted polio.

George had a heart attack in his late 50s while working for Philbrick Logging Company. After the heart attack, he had to quit working, and his only income was from social security. Not only did our father shun the social rules of mainstream Caucasian society, but he also did not marry a Chinese woman as his brothers and sister expected. Even though Yip Lee, our grandmother, accepted our mother into the family, that was not the case with my father's siblings. When we would visit my Dad's siblings, they would only speak Cantonese, knowing full well that our mother and her children were not bilingual. My mother would tell us stories of how she would spend time visiting and helping our grandmother. I asked our mother if Yip treated her differently because she was not Chinese, and she said no.

As I mentioned earlier, George Hee, in his younger years, had a sundry shop with a pool hall. My father's friends used to say that he was quite a pool shark. At the time, none of my siblings understood what that meant. Even though our parents made our life seem normal, the community in Mendocino did not treat us as equals. In our childhood, the continued name calling when we were simply walking down the street or participating in school sport activities was very hard for us to endure. It always seemed that my brothers were the only ones picked up after curfew, and when an item went missing, my brothers were usually accused of taking it. When we started school, because our oldest brother, Raymond, was mentally challenged, the teachers expected all of us to have the same problem. We all silently persevered so that we would not shame our father.

In 1800, one would think in a remote area such as Mendocino County that most of the following anti-Chinese laws would not be enforced. However, these laws did manage to have an effect

on the Chinese population in Mendocino County. Listed below are the laws that were written especially for the Chinese.

Counties

1848–Mariposa County Mining Regulations: prohibits Chinese from mining.

1852–Columbia District Mining Regulations: prohibits Asians from mining.

1870–San Francisco ordinance: outlaws Chinese pole method to peddle vegetables and to carry laundry.

1873–San Francisco Laundry Tax: high tax on laundries that do not use vehicles.

1875–San Francisco Cubic Air Ordinance: health regulation aimed at clearing out Chinese ghettoes.

1880–San Francisco Anti-Ironing Ordinance: aimed at shutting down Chinese nighttime laundries.

1870–San Francisco: no Chinese can be hired on municipal works.

California State Legislature

1850–Miner Tax: charges all foreign miners $20 a month.

1852–Bond Act: requires all arriving Chinese to post a $500 bond.

1854–California Supreme Court Decision: Chinese are added to the 1850 statute prohibiting "Negroes" and "Indians" from testifying for or against a white person.

1856–Miner's Tax: is set at $6 a month.

1858–Exclusion law: prohibits Chinese or Mongolians to enter the state unless driven to shore by stress of weather or unavoidable accident. The penalty for violating this law was a fine of $400–$600 or imprisonment.

1860–Fishing Tax: tax on Chinese activities in fishing.

1875–Fishing Act: regulates the size of Chinese shrimping nets.

1879–California's second constitution: prohibits any employment of Chinese by any corporation, state, municipal, or county governments.

1879–Fishing Act: Chinese prohibited from engaging in any fishing business.

1879–Act to Prevent the Issuance of Licenses to Aliens: Chinese unable to get licenses for businesses or occupations.

1882–California Legislature: declares legal holiday to allow public anti-Chinese demonstrations.

1885–Political Codes amendment: Chinese prohibited from public school; attend separate public schools.

1887–Penal Code: fishing license tax aimed at Chinese fishermen.

1891–Act Prohibiting Immigration of Chinese Persons into State: prohibits Chinese entry into California.

1893–Fish and Game Act: prohibits use of Chinese methods (nets) of fishing.

Federal

1879–Congressional Act: limits the number of Chinese that can come over on one ship at a time (15).

1879–Burlingame Treaty Amendment: prohibits entry of Chinese laborers.

1888–Scott Act: prohibits Chinese re-entry after leaving temporarily.

1892–Geary Act: prohibits Chinese entry; prohibits Chinese right to bail and habeas corpus procedures; Chinese must possess residence certificates.

1902–Congress extends indefinitely all laws related to Chinese immigration.

1943–Roosevelt repeals all the Chinese exclusion acts.

This book is only a small portion of the history of the Chinese in Mendocino County. In writing this book, I discovered there are more questions to be answered. This will require continuing research.

One

OCCUPATIONS

It has been documented that the Chinese were known to work in various occupations, such as in laundries and as cooks. History acknowledges that the Chinese were also the main labor force in building the railroads; however, very little credit is given to them for their contribution to the beginning of the wine industry, farming, or their distinctive cuisine. Chinese labors worked in the vineyards in Napa Valley, taking care of the grapes or digging large storage tunnels for the vineyards. Today, little to nothing is said about their contribution to this industry in California. One could also find that they became dairymen, miners, woodcutters, and vegetable growers, as stated in Ruthanne Lum McCunn's book, *An Illustrated History of the Chinese in America*.

Because of the distance of Mendocino County from San Francisco, one would assume the remoteness would make the county immune to the ongoing anti-Chinese movement within the labor unions in the 1800s. Unfortunately, the labor unions did play a pivotal role in fostering their anti-Chinese sentiment into the county population, as will be clearly illustrated in the Fort Bragg and Westport sections. In a recent book, *Driven Out: The Forgotten War against Chinese America*, it was noted that the Chinese were ousted in the major towns within Mendocino County. However, this author did not find any documentation to support that Gualala and Mendocino were participants. As a matter of fact, the Mendocino *Beacon* of February 27, 1886, states: "Point Arena had an anti-Chinese meeting last week, and appointed an executive committee. Mendocino is said to be the only place in the county where the political pot is not fairly boiling." It has also been clearly documented that there were larger populations in the towns of Gualala and Mendocino. One has to ask, if the expulsions were as effective as this recently published book discussed, how is it that the fourth generation of the first Chinese settlers of Mendocino could still be here? If the expulsion did take place, why wasn't the Hee family driven out and the Taoist temple destroyed? Even though the book's information is not correct about all the towns in Mendocino County, it is still an important piece of work that documents the systematic driving-out of the Chinese in California and other states.

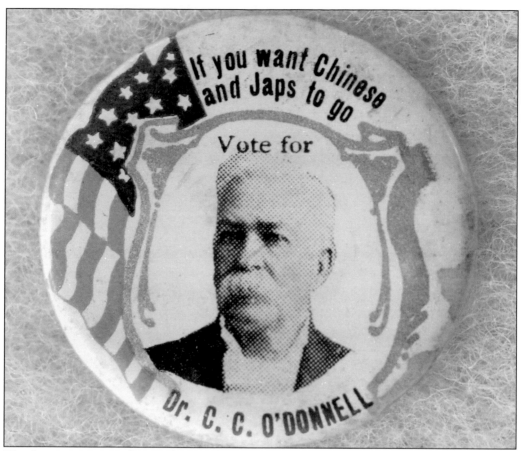

This button was created around 1876, when Dr. C. C. O'Donnell ran for mayor in San Francisco on the anti-Chinese ticket. His campaign platform was to run out all the Chinese in San Francisco within 24 hours after he was elected. (Courtesy Elaine Hamby of Willits.)

Above is a c. 1900 picture of the Chinese laundry on the west side of Main Street in Mendocino. The building is no longer standing. (Courtesy Loretta Hee McCoard, Escola Collection.)

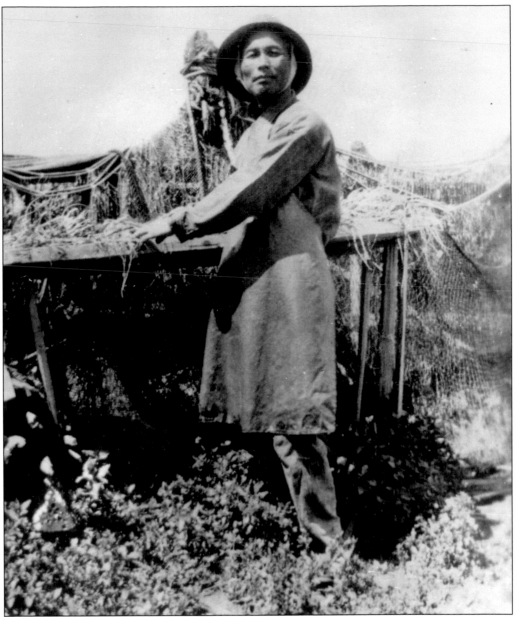

The Chinese took advantage of what the sea had to offer, and in the 1800s, they were the ones who really brought attention to what could be harvested. Not only did the Chinese harvest fish, but they also introduced the abalone to the world. It is noted in *A History of the Chinese in California* by Thomas Chinn that the Chinese were seen harvesting the mollusk in 1856. By the 1870s, the Chinese abalone junks were a common sight in San Diego. In 1860, the shell of the mollusk was also prized for jewelry. Fishing was the key industry, but there were many other specialized industries, such as the harvesting of sea algae, shrimp, and abalone along the Mendocino coast. The Chinese would pick sea palm and sea lettuce, dry the algae, and then sell them in San Francisco to later be shipped to China. The abalone was also dried and its shell exported and sold in China. This picture shows the drying of shrimp from the harvesting along the Mendocino coast. (Courtesy Kelley House Museum.)

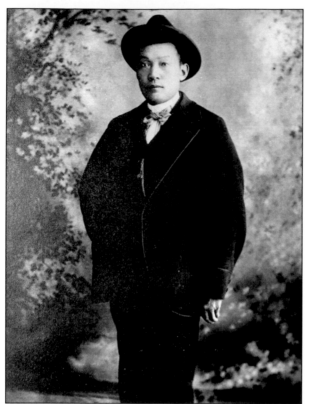

The Chinese had various businesses throughout the city of Ukiah, but they were mainly cooks and laborers. There were some lumber mills inland, but they were not as abundant as on the coast due to shipping costs over land versus sea. This is Waugh, the head laundry man at the Palace Hotel, Ukiah, around the 1900s. (Courtesy MCHS, Robert Lee Collection, No. 08368.)

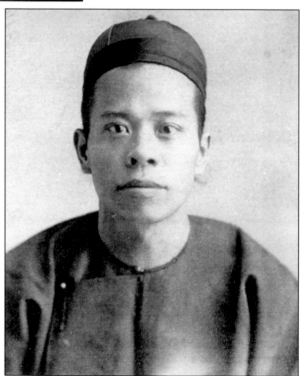

Pictured here is Lung, who worked as a cook at the Palace Hotel around 1897. The Palace Hotel is still in Ukiah but is abandoned. (Courtesy MCHS, No. 08369A.)

There was a Chinese presence in Ukiah even though the city tried to restrict their commerce. Shown here is additional Chinese help at the Palace Hotel around 1897. In the photograph from left to right are Lung the cook, Sam, and Low. (Courtesy MCHS, No. 0869B.)

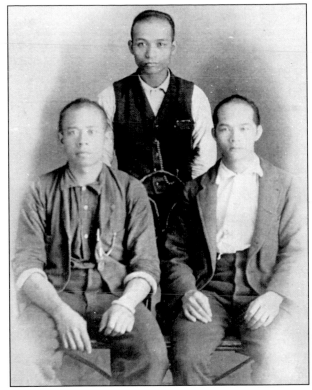

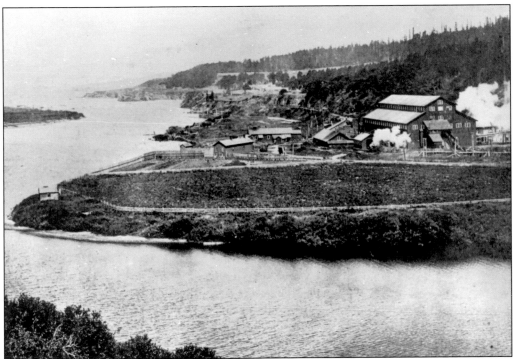

This is the Gualala mill from the south side. On the left side is China Gulch, where all the Chinese laborers resided in 1876. (Courtesy MCM, Escola Collection, 2000-14, Bdr 3, 59A.)

The town of Gualala is located on the furthest southwest corner of Mendocino County. Its name comes from the Pomo Indians and means "where the river comes down." The photograph shows the ferry crossing the Gualala River. The person operating the ferry is Chinese. (Courtesy MCM, Escola Collection, 2000-14-79.)

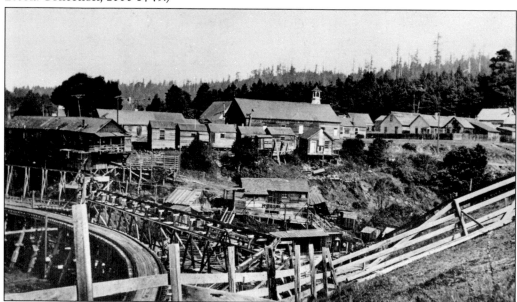

Gualala, as well as Mendocino, housed the largest concentration of Chinese people along the coast. Gualala's south end of town, by the river, was China Gulch, named after the Chinese who resided there. The Gualala mill was at the mouth of the Gualala River, and east of the mill were the shanties of the Chinese community. China Gulch is shown here looking north to Gualala. It was on the southeast end of the mill. (Courtesy MCHS, Robert Lee Collection, No. 3985.)

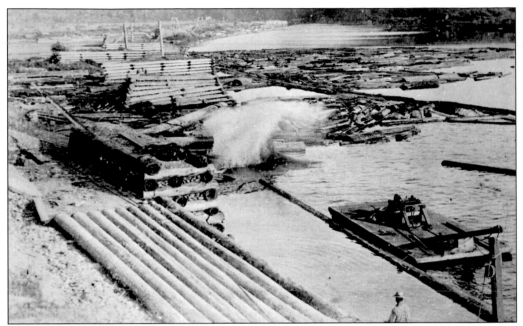

Gualala is documented to have the first lumber mill in the area, built in 1840 by Isaac Graham. Most people assume that all the lumber along the Mendocino coast came from redwoods, but in Gualala, one of the biggest industries was harvesting tanoaks. Tanoak tree bark contained tannic acid, which was in great demand where leather was tanned. Before harvesting, the bark of the tanoak would be peeled off. This photograph looks up river at the Gualala Mill Pond. The cribbing was built by hand by the Chinese. (Courtesy MCHS, Robert Lee Collection, No. 4019.)

By 1893, due to the anti-Chinese movement, all the Chinese in the Gualala Mill were replaced. On September 22, 1893, the *Record*, Gualala's newspaper, actually stated: "we are pleased to see Chinamen in the mill had been replaced with white laborers. It is said the mill is running cheaper and the men are more congenial than they use to be." This is what the Gualala Gulch site looks like today. This photograph looks north toward the mouth of Gualala River. (Photograph by Jeff Kan Lee.)

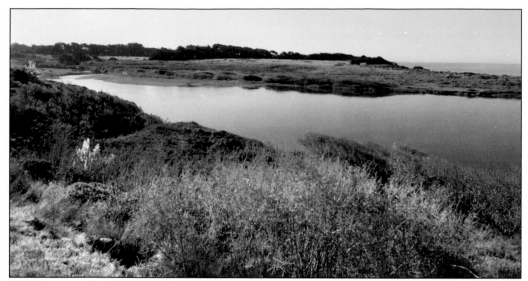

Whether it was because of the anti-Chinese movement or the lack of work, there were few Chinese persons residing in Gualala after 1893. It was noted in 1915 that there were two men who still lived in Gualala: Ah On and Ah Bing. Ah On lived near Gualala and was known for his deeds of kindness, such as sharing abalone, his first vegetables, and other things. He would gather seaweed for several months during the year, store it on George St. Ore's field near the ocean, and later ship it to China. Shown here is the site on the south end of town where the Gualala Mill once stood, looking south. (Photograph by Jeff Kan Lee.)

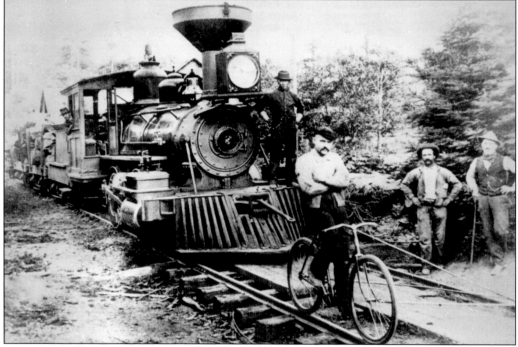

According to John Biaggi, the Gualala train, shown here, was at one time run solely by Chinese personnel. This photograph shows engineer George Williams, fireman Ah Quick, and Pete Generio, a saw filer on his personal track bike. (Courtesy MCHS, Robert Lee Collection, No. 0523.)

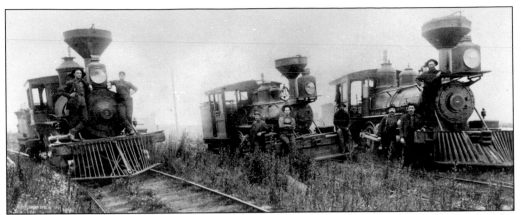

The information we have today is that the Chinese worked as cooks and laundrymen on the North Coast. In Gualala, they worked as house servants, water boys (also known as water slingers), cooks, and as engineers on the trains that carried the lumber on the rails around the mills. This is a photograph of all the trains at the Gualala mill. Posing are the men who operated the trains. (Courtesy MCM, Escola Collection, 2000-14 Bdr 3, 599.)

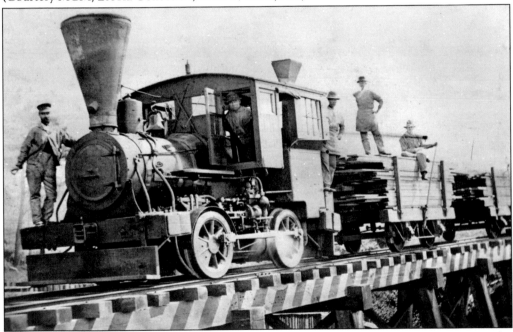

Pictured from left to right are Chester Byme, the donkey engineer; Ah Bing, the fireman in the cab; an unidentified Chinese water boy behind the cab; another unidentified Chinese laborer; and Ben Amey, the woods boss, at the rear of the train. Ah Bing was described as a "big husky Chinaman." It was said that he spoke English well, was able to fix things that were hard to mend, and was a "good man around steam." He held the position of last engineer on engine No. 4 and would travel back and forth between Mill Bend and Bourn Landing through the 1920s. Bing lived in China Gulch in a stilted hut, growing a garden and supplementing his diet with fish from the river. Bing had a friend, Otto Rueter, who would send down wild game meat after taking their skins. Bing had a family in San Francisco who came to visit in the summers. When Bing got old, he moved back to San Francisco. It has been said that, after his death, Ah Bing's body was shipped back to China. (Courtesy Robert Lee.)

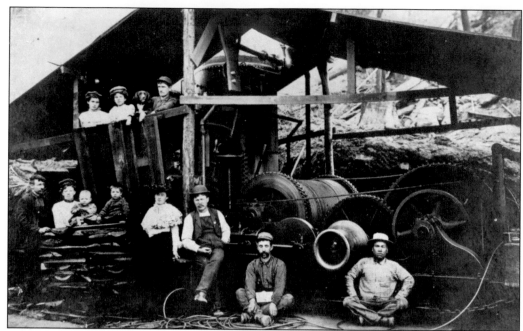

This is a donkey skidder, the first mechanized system to pull logs along the ground. The people in the photograph are, from left to right, (first row) George Williams, Mrs. Williams, Dorothy Williams, Howard Williams, unidentified, Martin Cook, Chopper, and Oh Mau, the pool tender; (second row) Mrs. Weatherby's sister, Mrs. Weatherby, and Jack Weatherby. (Courtesy Robert Lee.)

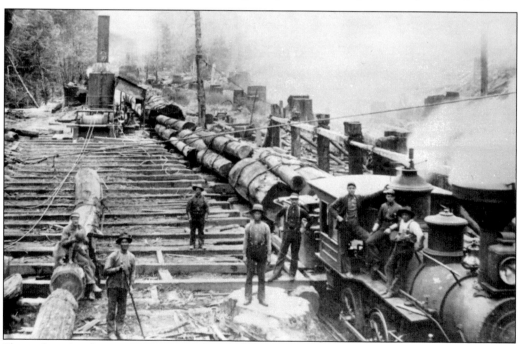

Shown here is a locomotive train in the Gualala woods around 1905. From left to right, the men are Emil Johnson, unidentified Chinese person, Roy Hale, Ah Bing, George Williams, engineer Joe Bishop, Sid Baker, and Lester Baker. (Courtesy MCHS, Carpenter print, No. 0398.)

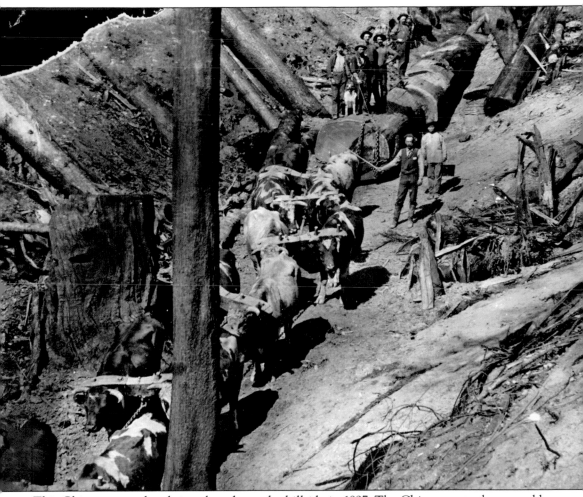

This Chinese water boy brings logs down the hillside in 1897. The Chinese water boys would spread water over the trails so that the logs could slide down the hillside to the river. (Courtesy MCHS, Robert Lee Collection, No. 1067.)

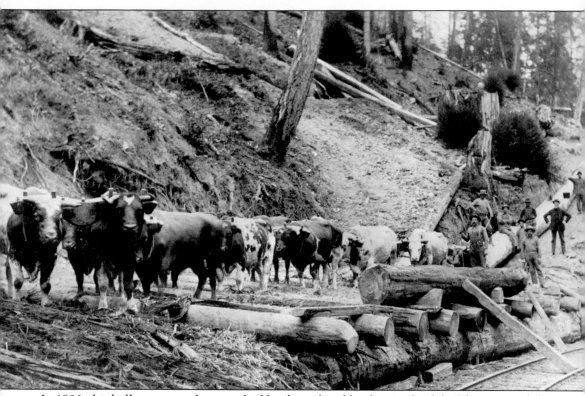

In 1886, this bull team was photographed by the railroad landing in Gualala. The man with his hands on his hips is team boss Ben Severance. (Courtesy MCHS, Escola Collection, No. 4902.)

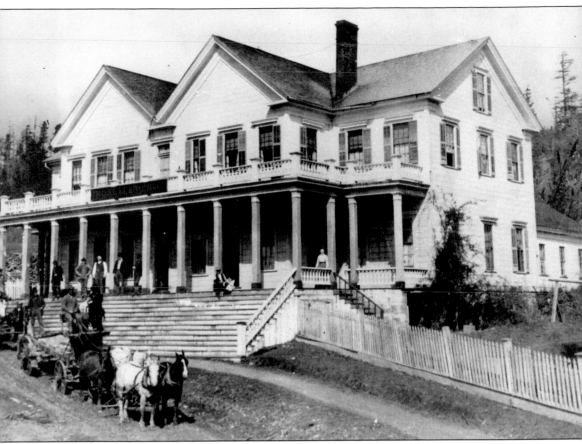

In 1978, the author interviewed John Biaggi, whose parents ran the Gualala Hotel at one time. One of Biaggi's fondest memories was of the Chinese cooks his father employed. He said the food was good, especially the pies that would be cooled on the open windowsills of the hotel. Unlike those in the Gualala area, the Chinese of Point Arena and Elk worked mainly in the mills and agriculture areas. According to John Biaggi, the Chinese would harvest the algae (seaweed) from the sea and rent a hall in Point Arena to dry it. Later, they would take the product to San Francisco to sell. The Chinese in Point Arena were not as prevalent as in Gualala. Very little is documented in regards to the Chinese presence in the Point Arena community. This hotel is still operating in the town of Gulala. (Courtesy MCHS, Escola Collection, No. 4490.)

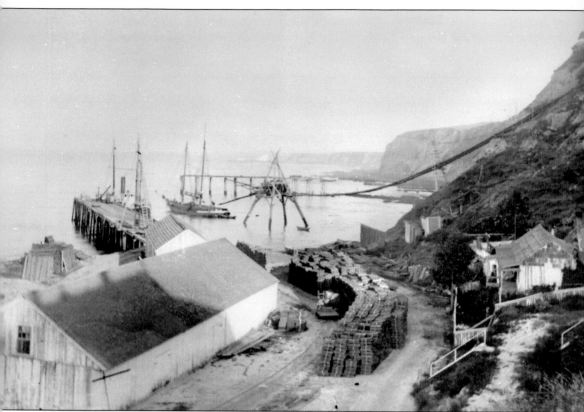

Unlike the Chinese in the Gualala area, those in Point Arena and Elk worked mainly in the mills and agricultural areas. One story told by John Biaggi, an elderly gentleman, is that the Chinese would harvest the algae (seaweed) from the sea and rent a hall in Point Arena to dry the algae. They would later take the product to San Francisco to sell. The Chinese in Point Arena were not as prevalent as in Gualala. Very little is documented in regards to the Chinese presence in the Point Arena community. This is the Point Arena Mill from the west end to the Pacific Ocean. Logs were sent down the chute to be loaded onto ships. One can see the pier where the boats would tie up. Today there is very little that resembles this original mill. (Courtesy MCM, Escola Collection, 2000-14, Bdr 4 80A.)

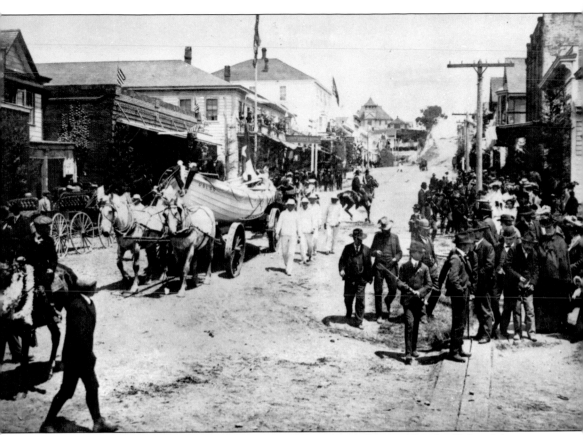

Looking north, this is the view from Point Arena's Main Street during a Fourth of July celebration. The mill, not in view, was located at the southwest side of Point Arena. No date is available for the photograph. (Courtesy MCM, Escola Collection, 2000-14, Bdr 85.)

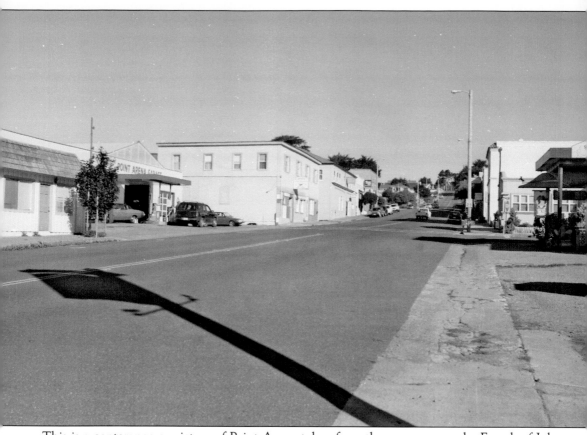

This is a contemporary picture of Point Arena taken from the same spot as the Fourth of July parade on the previous page. (Photograph by Jeff Kan Lee.)

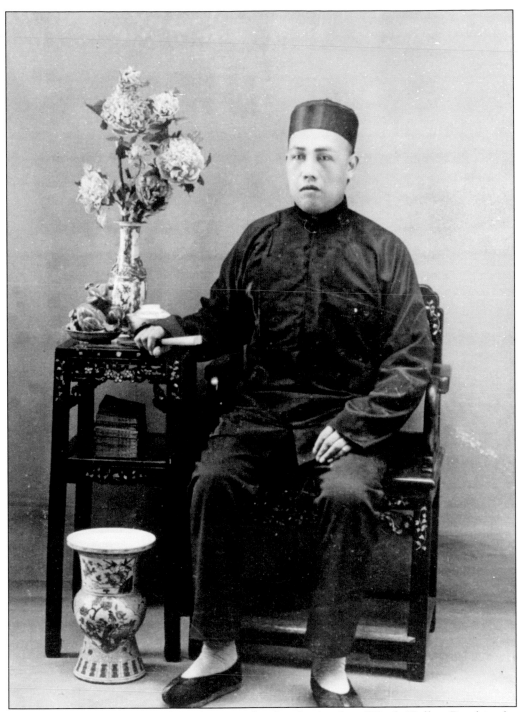

Jim Mok, shown here, cooked for the Gain family, who lived on Windy Hollow Road in the Manchester area just north of Point Arena. (Courtesy Robert Lee.)

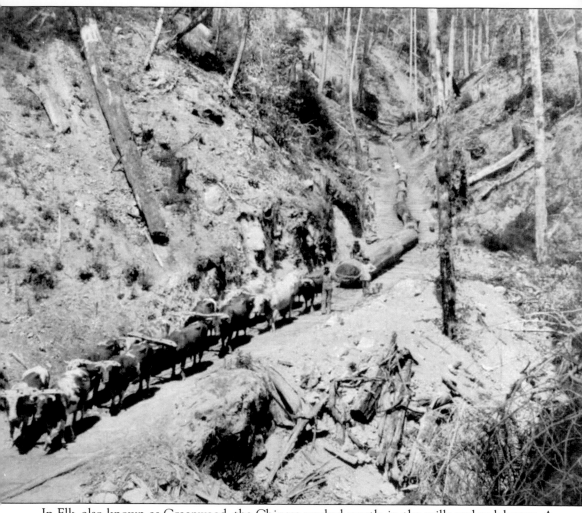

In Elk, also known as Greenwood, the Chinese worked mostly in the mills and as laborers. A Chinese water boy stands on the side of this trail with a bull team in 1895. (Courtesy MCHS, Robert Lee Collection, No. 1085.)

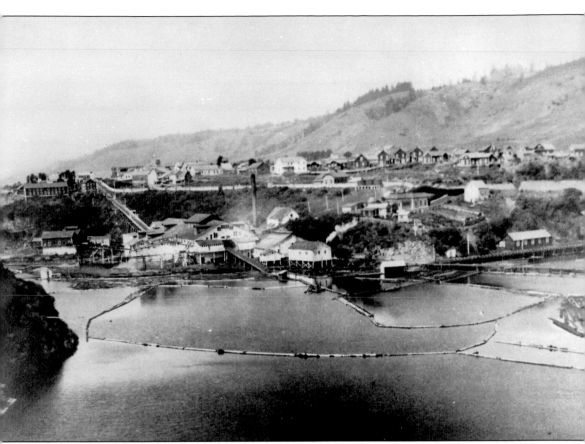

This is the Elk mill. This mill was called the Greenwood Creek Mill and was owned by Charles Crocker. The above pictured was taken around 1882. This mill produced around 40,000 to 50,000 board-feet of lumber. (Courtesy MCM, Escola Collection, 2000-14 Bdr 21 902.)

This is a contemporary picture of what was once the Greenwood Creek Mill of 1882. (Photograph by Jeff Kan Lee.)

This group of people on a push car are, from left to right, (first row) Edna Philbert, Mary June Maddox, Lureen Maddox, Laurence Maddox, Mrs. Philbert, Lola Philbert, and Al Philbert; (second row) Mr. Brown, an unidentified Brown child, Mrs. Brown, an unidentified Philbert child, Lee Brown, an unidentified Chinese person, and Marion Philbert. (Courtesy MCHS, Robert Lee Collection, No.1087.)

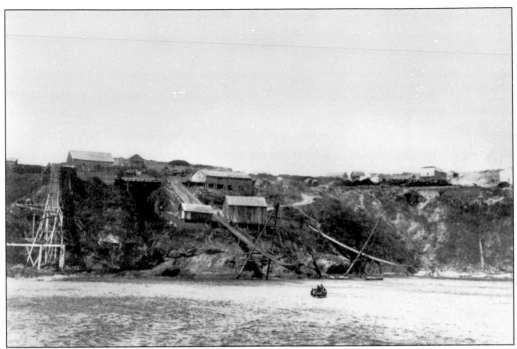

This is Cuffey's Cove, north of Elk, in 1890. The area had a small mill built on the edge of the cliff, which made it easier to load logs onto the ships. (Courtesy MCM, Escola Collection, 2000-14 Bdr 21 952.)

There is written evidence that one Chinese man, Charlie Li Foo, pictured here, resided in the town of Elk. He was a woodsman and an informal banker to the Chinese. According to an advertisement placed in the *Mendocino Beacon* of May 4, 1878, Li Foo was also a barber: "Charles Li Foo, Cuffey's Cove, California. Barber Shop and Bath House, Hot and Cold Baths at All Hours. Also Dealer in fruits and Nuts and Confectionary. My Motto: Please Customers." (Courtesy Robert Lee, Escola Collection.)

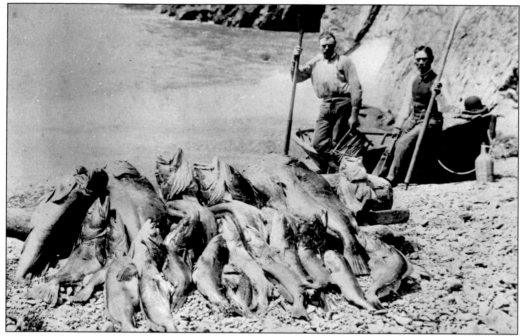

Charlie Li Foo and friend's catch along the coast of Elk in the late 1800s is mostly Ling cod and other rock fish. The quantity is quite remarkable. Today there are restrictions on the size and quantity one can catch daily. Li Foo owned a shop on Main Street in Elk and rented a house owned by the White Lumber Company. He died in 1898 working in the redwoods. The *Mendocino Beacon* reported, "A falling tree pinned his leg to the earth, and when found he was trying to extricate himself by amputating his leg with a pocket knife. He was thoroughly Americanized, generous and greatly esteemed by the people generally. His funeral on Saturday was very largely attended." (Courtesy MCHS, Escola Collection, No. 1746.)

This is a picture of another Chinese person in Elk. His name was not available. Because he is wearing the traditional Chinese clothing, one could speculate that he worked as a house servant for one of the local families. (Courtesy MCHS, Robert Lee Collection, No. 14992.)

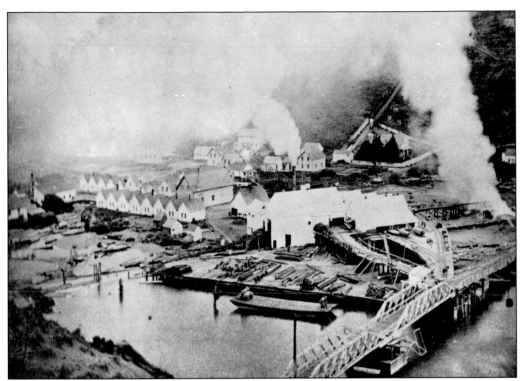

This is the Navarro Mill around 1885. Again, there is little known about the Chinese at the Navarro Mill or where they may have resided inland from the Navarro River. (Courtesy FBMCHS, C3F139.)

This is what the Navarro River looks like today. The picture shows the mouth of the Navarro River and the large entrance to the sea. It is now part of the California State Park system. (Photograph by Jeff Kan Lee.)

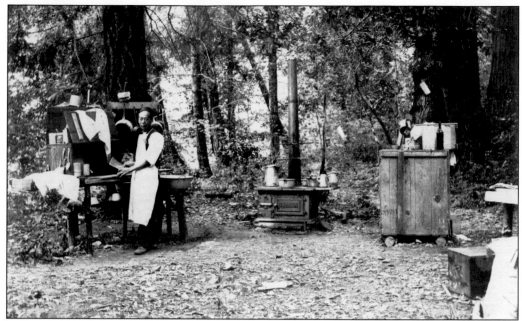

This 1895 photograph shows Grace Hudson and her family camping along the Navarro River in the summer to escape the heat. Soon Quong Wong is at the worktable preparing a meal. (Courtesy GHM, Grace Hudson's personal collection.)

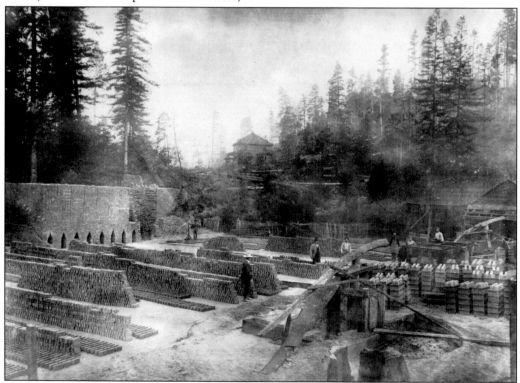

This is a brickyard in Navarro. In the far back is a person dressed differently who is possibly Chinese. (Courtesy MCM, Escola Collection, 2000-14b Bdr 51 2342.)

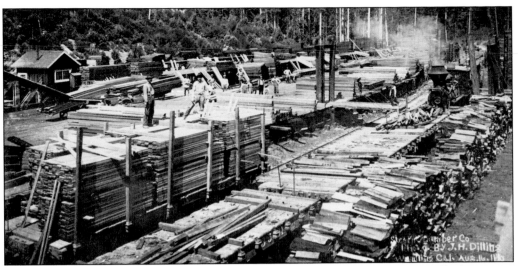

One of the pictures of a mill in Navarro from 1905 shows the Stearn's Mill. (Courtesy FBMCHS, C3F139.)

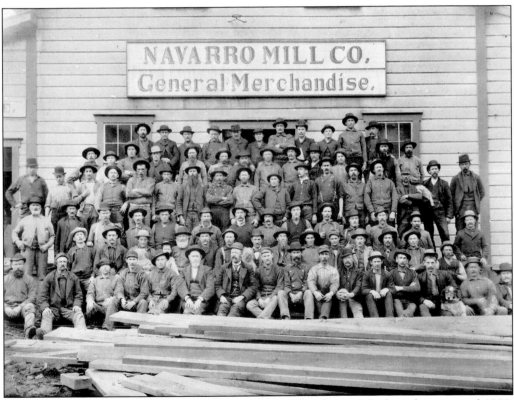

The employees of the Navarro Mill are shown here. The photograph dates from around 1900. (Courtesy FBMCHS, C3F1309.)

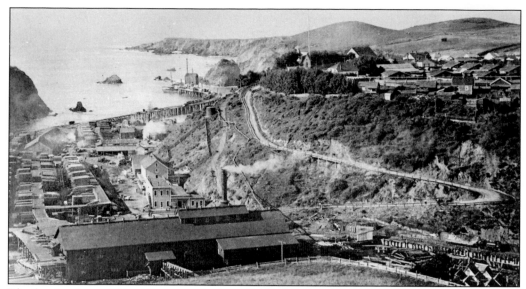

The first lumber mill in Albion was built in 1844 by Capt. William (Guillermo) Richardson. He became a Mexican citizen, making him eligible for a land grant. He built a tidal-powered mill, which was destroyed by high winter water several years later. Another mill was built in 1852 along the Albion River where the Chinese worked as cooks and laborers. There was a succession of mills at the same site until 1928. The last company to have a mill was the Albion Lumber Company, shown here, who bought the Navarro Lumber Company in 1920. The materials produced were used in the construction of the railroads in the Southwest and Mexico. (Courtesy MCM, Escola Collection, 2000-14, Bdr 6 184.)

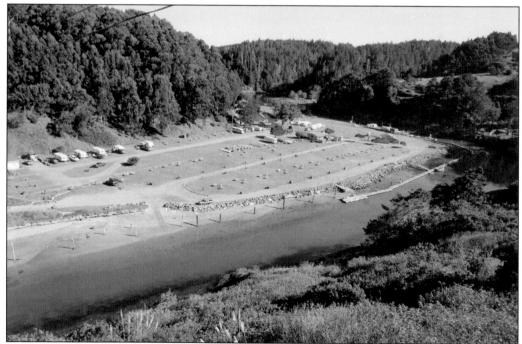

This is a current photograph from the Albion Bridge on Highway 1, the same site as the previous picture. (Photograph by Jeff Kan Lee.)

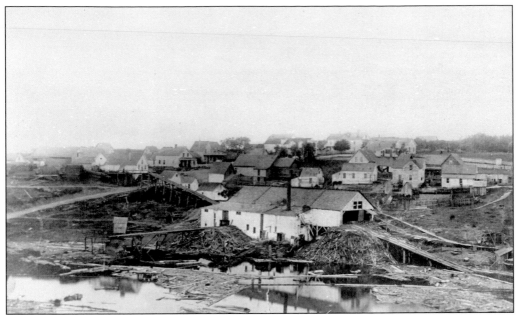

Little River also had a lumber mill near the mouth of the river. There were several mills in the Little River area, but only two were built on the north side of the river. This mill built on the north side was co-owned by Silas Combs and eventually burned down. The second closed due to the financial Panic of 1893. Below is a picture of one of the north-side mills of Little River in 1870. (Courtesy MCM, Escola Collection, 2000-14, Bdr 18 752.)

One mill was built on Little River Airport Road, southeast of the river. This mill produced wooden shakes and shooks. A shook was a redwood box used to ship huckleberries. This is what Little River Beach looks like today. This site is part of the California State Park system and is currently known as Van Dam State Park. (Photograph by Jeff Kan Lee.)

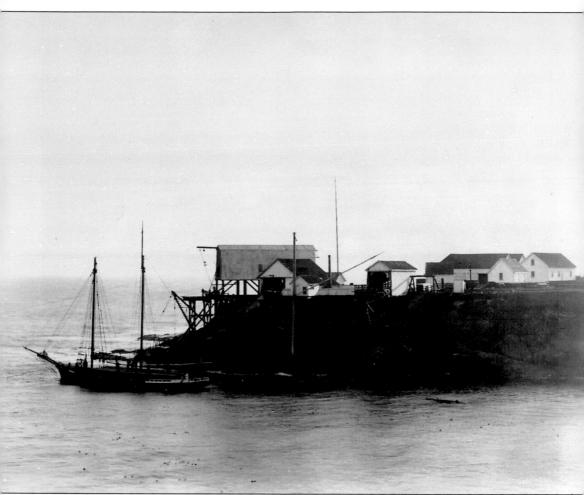

Mendocino was one of the few towns that had a substantial Chinese population, and the Chinese in Mendocino held many different types of jobs. They were cooks, house servants, shop owners, and water slingers. Water slingers spread water over the trails so that the logs could slide down the hillside to the river. They carried a pole on their shoulders, and at the end of each pole was a large basket or bucket of water they would swing around to wet the hillside. For the mills, they were the key to easing the logs down to the river. This is a photograph of the first lumber mill in Mendocino, taken in 1853. Today this is the southern point of the Mendocino Headlands State Park. (Courtesy MCM, Escola Collection, 2000-14, Bdr 11 474.)

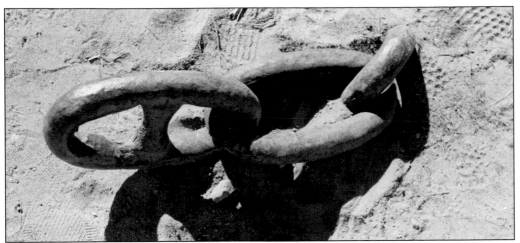

It is said that, if it had not been for the wreck of the Baltimore clipper *Frolic* near Point Cabrillo in 1851, the first mill would not have been built in Mendocino. After the accident, Harry Meiggs, the owner of the vessel, sent men to salvage the cargo. They found a much more valuable commodity in the redwood forests, and the first mill was built in 1852 on the bluffs, which are now the Mendocino Headlands. This is what remains of Mendocino's first mill. Chains like these were used to tie the ships while workers loaded the logs. (Photograph by Jeff Kan Lee.)

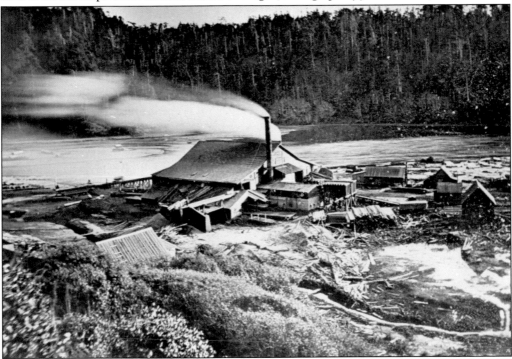

Due to the difficulty of moving large redwood logs up to the mill, there were many delays in their harvesting. The logs were kept at the mouth of the river in an enclosure that continually broke from high river water and ocean storms, which caused production delays. Meiggs Mill only lasted until 1855. Pictured here is the Page Mill, built in 1855 east of Mendocino along Big River, a location free from the problems the Meiggs Mill encountered. (Courtesy MCM, Escola Collection, 2000-14, Bdr 11 512.)

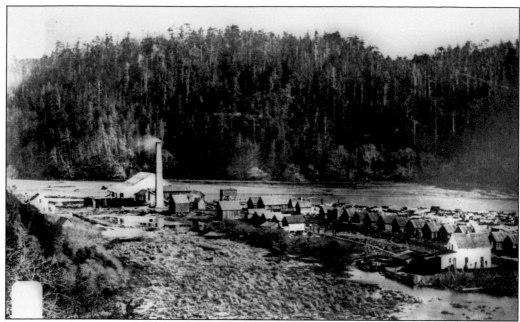

This is another shot of the Page Mill in Mendocino. The housing built around the mill is clearly visible. (Courtesy Kelley House Museum.)

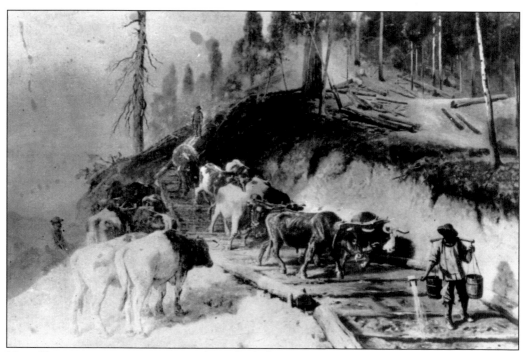

Here Chinese water carriers move along the hillside with an oxen team. Note that the water slinger is spreading water, a key to easing the logs down the hillside to the river. (Courtesy Kelley House Museum.)

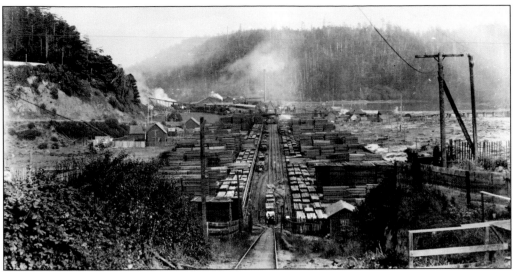

Shown here is a Wanocott photograph of the Mendocino Lumber Company in 1920 at Big River, east of Mendocino. (Courtesy MCM, 83-27-840.0.)

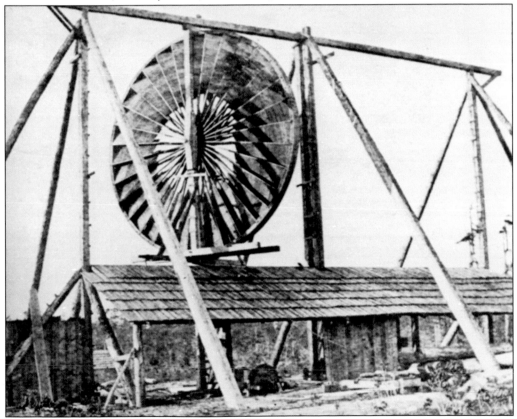

This is the William Heeser Mill, built in 1890. The structure was wind-powered and built east of Mendocino out of the prevailing winds. Even though Heeser's wind concept was an innovative way to power the building, the mill failed. If the technology we have today had been available to Heeser, the mill may have been a success. (Courtesy FBMCHS.)

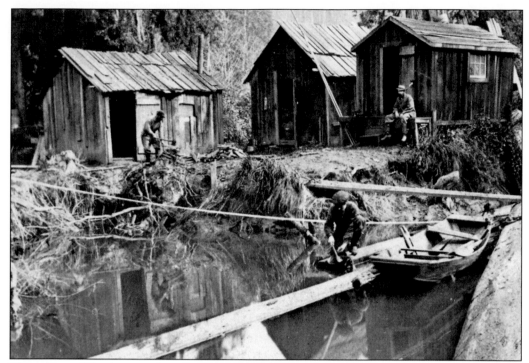

This is Boom Woods camp along Big River in 1876. The Chinese cook is washing a pot in the river. The above is a temporary camp for the workers. Most of the men lived full-time at the camps and only left in winter to live in town. (Courtesy MCM, Escola Collection, 2000-14, Bdr 12 563.)

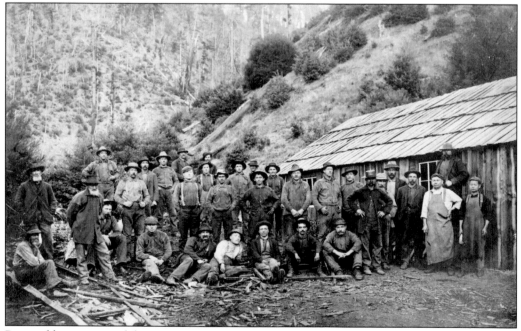

Pictured here is one of the camps at Boom Woods. Chinese cooks are pictured on the far right. There were many temporary camps set up along Big River to house the many lumberjacks. (Courtesy MCM, 2000-14, Bdr 14 737.)

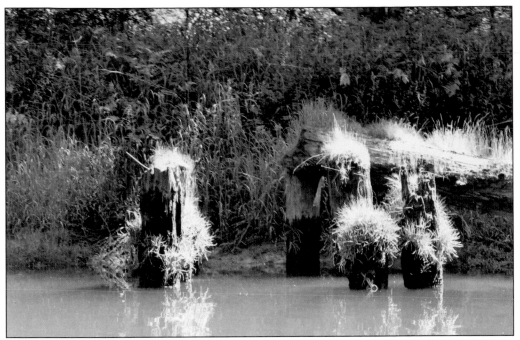

These are the remnants of one of the booms along Big River. The boom (or dam) was where logs were held until they were sent down to the mill for processing. Big River had an elaborate system of 27 booms. They were used to retain the winter's rainwater and were then released in sequence. This flushed the logs down the river to the mill, much like the way the Panama Canal moves ships through its passages. (Photograph by Jeff Kan Lee.)

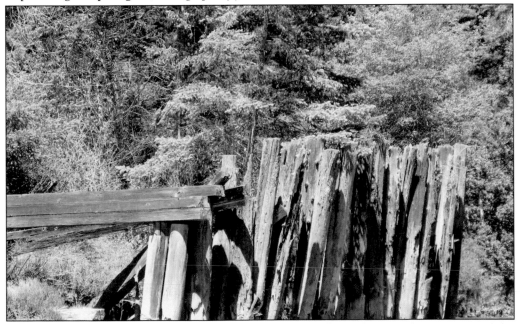

This is a current photograph of another boom along Big River. This is what remains of the many sites that held the logs in place before moving them down to the mill. (Photograph by Jeff Kan Lee.)

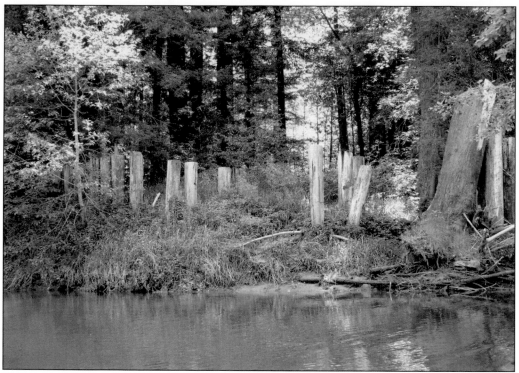

This is another contemporary photograph of a boom further up Big River. The two photographs on this page show what remains of the multiple booms built to keep the logs moving down the river. (Photograph by Jeff Kan Lee.)

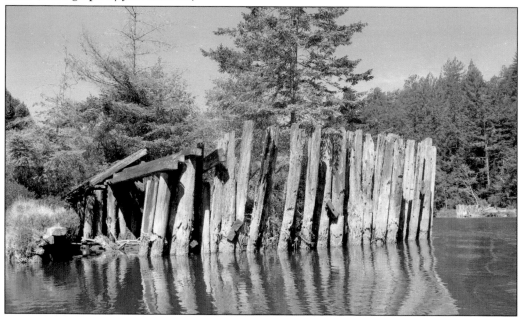

These are the remnants of another boom along Big River. When travelling up this river, one will see the series of booms along the shores, and if one did not know the lumber history, it would not be clear what these structures were used for. (Photograph by Jeff Kan Lee.)

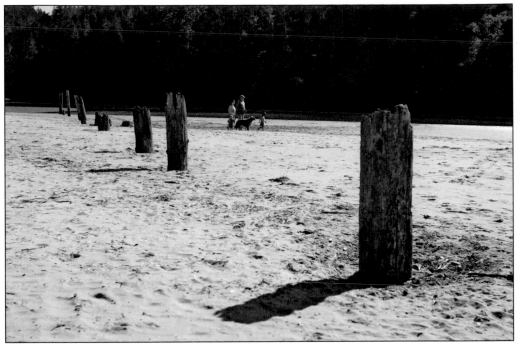

These posts on the east side of Big River's bridge were once part of the pier at Big River where the log rafts were tied before moving out to Mendocino Bay. (Photograph by Jeff Kan Lee.)

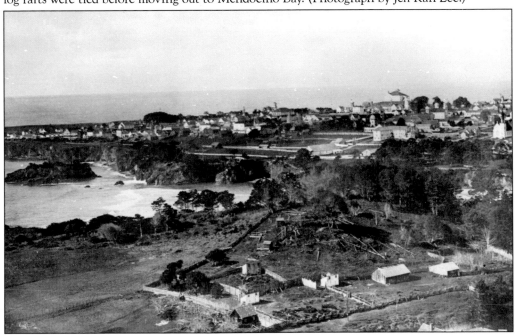

Historically, the Chinese played a major role in the California farming industry. Most of the Chinese immigrating to America had been farmers, so it only seems natural that they would seek work in agriculture. From the 1860s to the present, Chinese could be found working in every part of California's farming industry. Shown here are the Chinese gardens southeast of Mendocino in 1904. (Courtesy MCHS, Robert Lee Collection, Carpenter photograph, 2205.)

Across Big River and the town of Mendocino, the Chinese gardens, shown here in 1863, were an integral part of the Mendocino community. Highway 1 now divides the Chinese-leased land across Big River. On the southeast corner of the photograph is where the Stanford Inn, owned by Jeff Stanford, now stands. The Stanford Inn's yard, part of the Chinese gardens, still contains some of the original trees grown by the Chinese. To this day, there are two old apple and plum trees on the property. The gardens, leased by the Chinese, were used to grow vegetables and fruits that were later sold back to the town. In addition, the Chinese residents living along the Mendocino Headlands had small gardens beside their rented homes. The town of Mendocino was very isolated from the major metropolitan areas, therefore requiring the town to become self-sufficient. Wild kale that was once planted by the original Chinese settlers on the Mendocino Headlands can still be found growing wild. (Courtesy MCM, C. E. Watkins print, 2000-14, Bdr 9 371.)

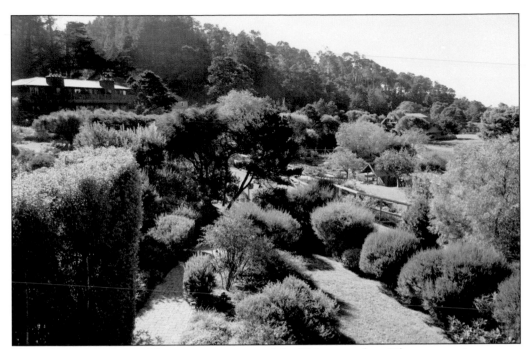

Shown here is a picture of the present property of the Chinese gardens. The property is now part of Stanford Inn. Several years ago, California's state archeologist inspected the property on the south side of Mendocino and found remnants of a tool shed and some tools. The author's father, George Hee, spoke often of the gardens. (Photograph by Jeff Kan Lee.)

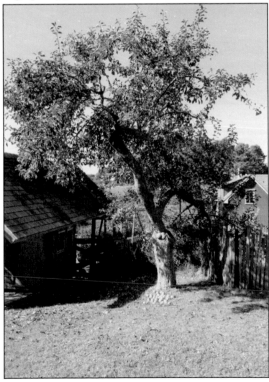

In addition to commercial gardens, there were Chinese-owned businesses that specifically catered to the Chinese, such as herb shops. The Chinese in Mendocino also owned restaurants and laundries. According to Jeff Stanford, owner of the Stanford Inn, there are two fruit trees original to the property, which was once part of the Chinese gardens. This is one of those trees. (Photograph by Jeff Kan Lee.)

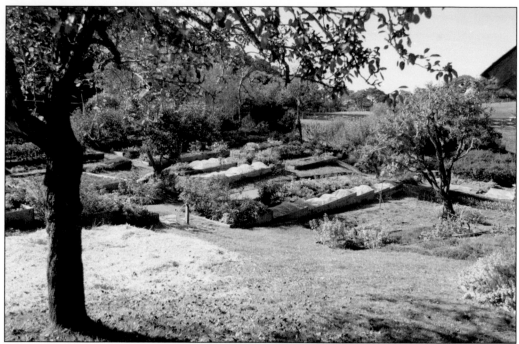

On the far right of this photograph is the second original fruit tree on this property left over from the days of the Chinese gardens. (Photograph by Jeff Kan Lee.)

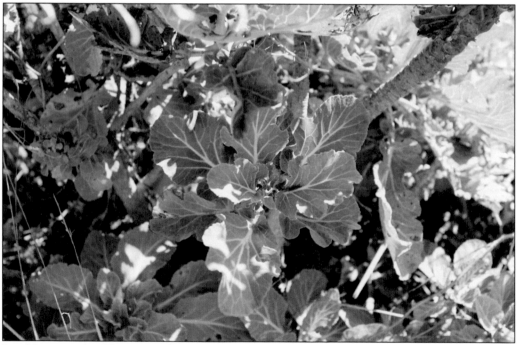

In addition to the Chinese gardens, little gardens were tended behind the shanties and Chinese buildings on the Mendocino Headlands. The wild kale growing there today are the descendants, now over 100 years old, of the original plants. This is a photograph of the kale that the Chinese planted, which still grows on the Mendocino Headlands. (Photograph by Jeff Kan Lee.)

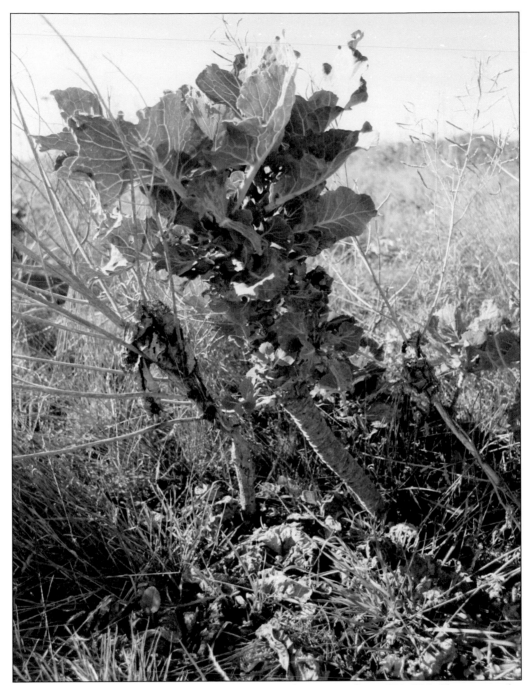

According to George Hee, grandson of Joe Lee, there were about 500–700 Chinese in the Mendocino area. To validate this statement, Mendocino City's Sanborn maps note five to seven Chinese herb shops located in Mendocino in the late 1870s. There would have to be a substantial Chinese population to support those businesses. There were small lumber mills throughout the inland area, and as history has shown, migrant laborers travel where their jobs lead them. This is another photograph of the kale that is still growing on the Mendocino Headlands. This plant is very tall and has been growing for many seasons. (Photograph by Jeff Kan Lee.)

Many writers and researchers state that there was not a large population of Chinese in Mendocino because the U.S. Census records did not show a lot of Chinese listed. To counter that myth, the argument could be made that those aware of the anti-Chinese sentiment that ran rampant in California between the 1850s and early 1900s would have feared deportation after making themselves known to any government entity. This is a current photograph of Mendocino looking down Main Street to the east. The open space in the front of the photograph was once Chinatown, its boundaries extending west on Kasten Street on to Kelly Street. This property is now part of the Mendocino Headlands State Park. To this day, one can walk around and see the wild kale. (Photograph by Jeff Kan Lee.)

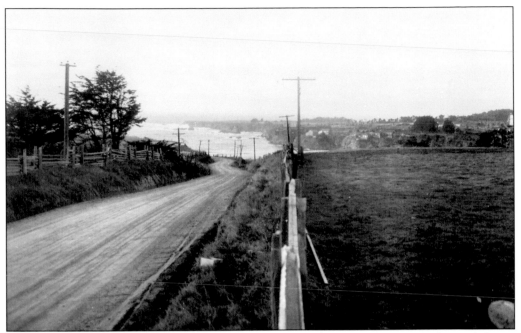

Moving north of Mendocino, one comes to the small town of Caspar, historically much larger than it is today. This is a photograph (date unknown) of old Highway 1, driving north. One can see the town of Caspar at the top of the frame. This is still a major highway in the county and a scenic drive. (Courtesy MCM, Wonacott photograph, 83-27-1364.)

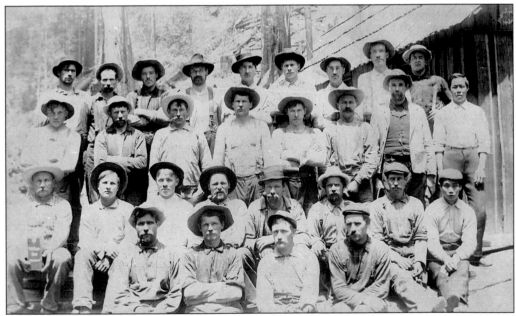

This is the Caspar woods crew, and at the ends of the second and third rows are Chinese laborers. It is unclear what these laborers did, but they are dressed in western clothing similar to the other workers. One could assume they were part of the crew. (Courtesy MCM.)

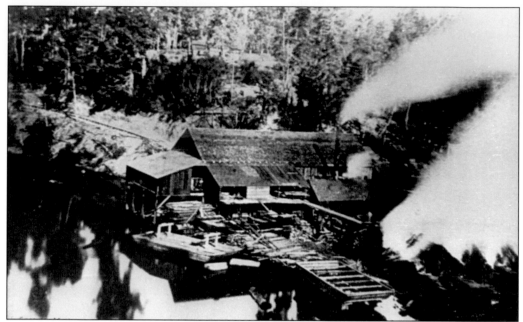

The first mill built along the Casper River (now known as the Casper Creek) was built in 1861 by William Kelly and a Mr. Rundle. The mill employed Chinese cooks. Today there is no evidence remaining other than a few photographs to prove the Chinese were ever present in the town of Caspar. The population in the late 1800s was much larger than the population today, and there are no Chinese residents. There is no major industry in the town of Caspar and, therefore, few residents. In researching Caspar, the author found one of the larger collections of photographs of the Chinese cooks. Shown here is a photograph of the first Caspar Mill. (Courtesy MCM, 2000-14, Bdr 7 259.)

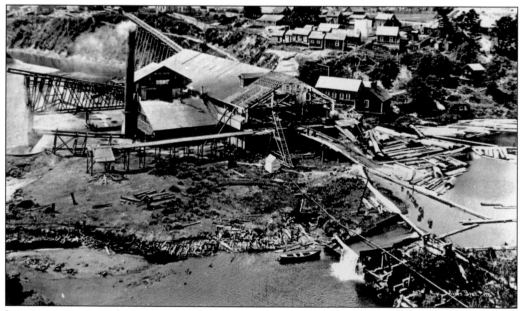

Later construction, shown here, built rail lines to transport the logs from the Jughandle woods north of Caspar. (Courtesy Kelley House Museum.)

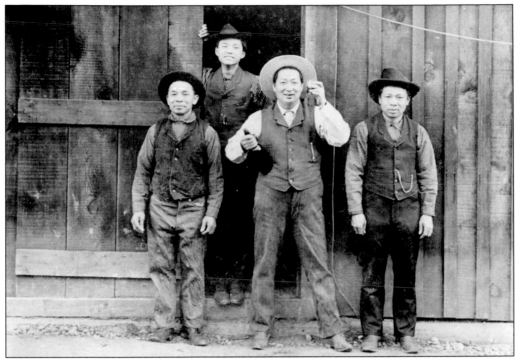

The following seven pictures show the Chinese cooks for the Caspar wood camps around the late 1800s. In this first picture, the cooks pose in front of a building at Camp No. 1. (Courtesy MCM, Escola Collection, 2000-14, Bdr 8 267.)

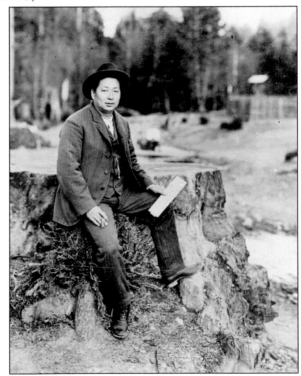

The man sitting on this sizable stump is Wah Bow, head cook at Camp No. 1. This photograph and the one previous show that he liked his cigars. (Courtesy MCM, Escola Collection, 2000-14, Bdr 8 265.)

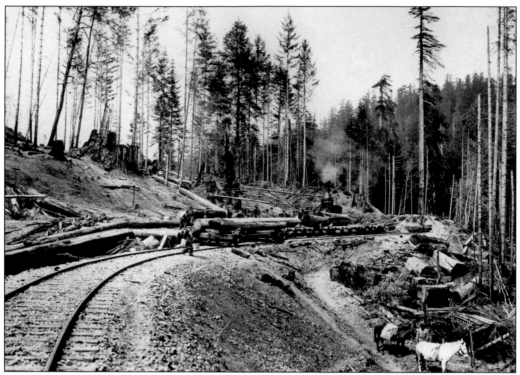

Here the Miles Brothers crew works the rail line through the Caspar woods. The worker beside the tracks is a Chinese water boy. (Courtesy MCM, Escola Collection, 2000-14, Bdr 56 247.)

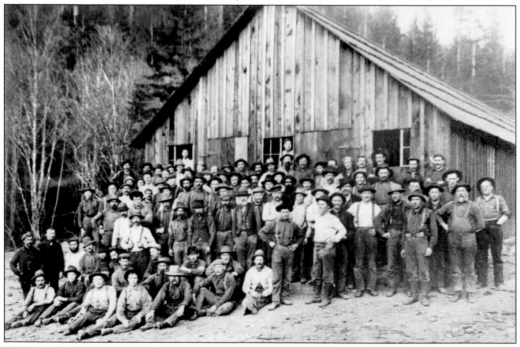

Here is Mr. Freathery's woods crew in the Caspar woods. In the windows are the Chinese cooks. (Courtesy MCM, Escola Collection, 2000-14, Bdr 7 233.).

The camp employed a Chinese person to do the wood crew's laundry at Camp No. 1. (Courtesy MCM, Escola Collection, 2000-14, Bdr 7 231.)

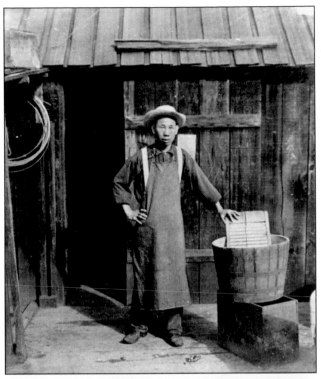

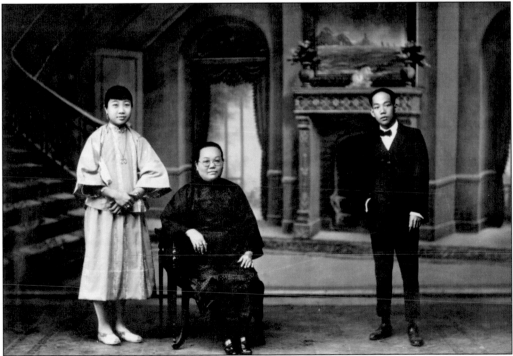

Chan Mun Hong, commonly known as Yippe Chan, was the cook for the Union Lumber Company in Caspar in 1942. Shown here from left to right are Yippe Chan's wife, his mother, and Yippe Chan. (Courtesy MCM, Wonacott photograph, 83-27-000093.)

Today very little evidence of the Caspar Mill remains. Pictured here are the posts left from the mill site on Caspar Beach. Posts are sometimes the only parts left today from various mills, as also seen in the present-day photographs of Big River on pages 43–45. (Photograph by Jeff Kan Lee.)

Two

CHINESE IN THE MEDIA

In earlier parts of this book, information was given concerning both anti-Chinese legislation and how the Chinese have participated throughout various communities in Mendocino County. To complete the picture, one has to read the local papers that kept the communities informed about the Chinese and their families. These articles had a profound impact on the Chinese settlers and their children. The papers always supported the laws but covertly implied their position on the Chinese. In the *Mendocino Beacon* on April 18, 1877, the paper wrote, "The Gualala mill was compelled to close down last week on account of a strike among the Chinamen." The article did not leave good feelings in the community, and yet the Chinese stood up for themselves.

In the July 15, 1882, issue of the *Mendocino Beacon*, it was stated that, "Our neighbors at Westport have been thrown in a state of excitement and perturbation by an unlawful attempt on the part of a certain persons to deprive those who have Chinamen in their employ. . . . If any person sees fit to employ Chinamen or any other class of help, the law gives him clear right to do so, and who ever attempts to forbid it will discover that the real issue is between him and the government under which we live." County officials tried to enforce the laws, but their efforts did not head off the expulsion of the Chinese in Westport, as reported in the *Mendocino Beacon* on March 13, 1885. Even though anti-Chinese sentiment ran high throughout the county, Mendocino did not join in. According to an article in the *Mendocino Beacon* on February 27, 1886, "Point Arena had an anti-Chinese meeting last week, and appointed an executive committee. Mendocino is said to be the only place in the county where the political pot is not fairly boiling."

Mendocino may not have participated in the political issue of the expulsion, but they did try to keep the Chinese separate from the general population, as seen in the *Mendocino Beacon* on July 2 and 27, 1889. The excerpts above are only a small portion of what was written about the Chinese in the local media throughout the years.

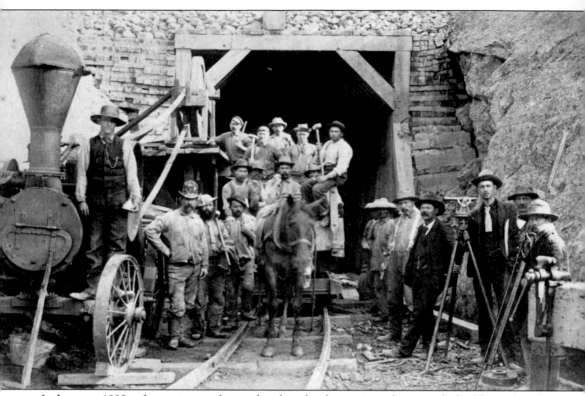

In January 1892, after union workers refused to dig deeper into the tunnel, the Union Lumber Company contracted Chinese laborers to dig the Noyo tunnel east of Fort Bragg by hand. The tunnel was built so the mill's train could transport lumber over the hill to Willits to later be shipped out on the Northwestern Pacific Railroad. It would become the major shipping route of all manufactured lumber in the area. The newspaper reported that six men from Fort Bragg were indicted for beating these Chinese laborers and dropping them off at the north end of the Noyo River, telling them to just keep walking. The Chinese walked to Mendocino and were taken in by the community. As reported by the *Advocate*, they were brought back under protective custody of the Mendocino County sheriff the very next day by the order of a Superior Court judge. Although now a tourist attraction, this rail still delivers mail to inland residents along the lines. Today the Chinese are acknowledged as those who dug the tunnel the Skunk Train excursion ride uses, but nothing is said about what these Chinese laborers endured. Shown here is the Noyo tunnel upon completion. Note that only two Chinese persons are pictured. (Courtesy Robert Lee, Escola Collection.)

Pictured here is the Noyo Mill in 1858. This mill was later moved to the top of the bluffs and became the Union Lumber Company, operating from 1892 to 1969. (Courtesy MCM, Escola Collection, 2000-14, Bdr 27 1197.)

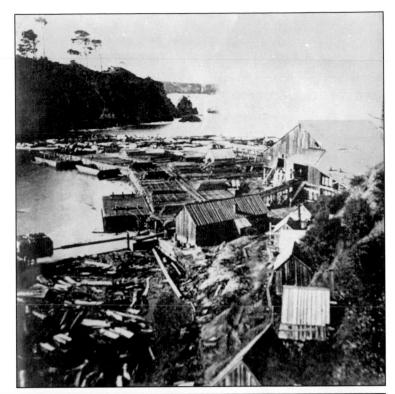

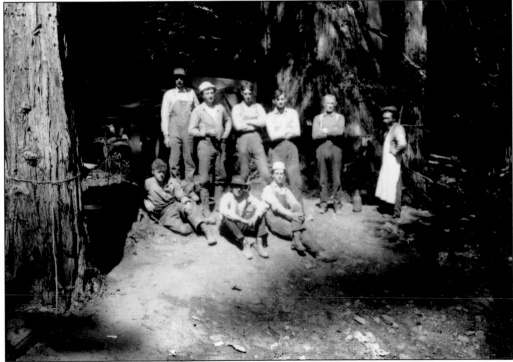

The Fort Bragg woods camp workers are seen here with their Chinese cook. (Courtesy MCM, Perkins Collection, 96-134-Woods.)

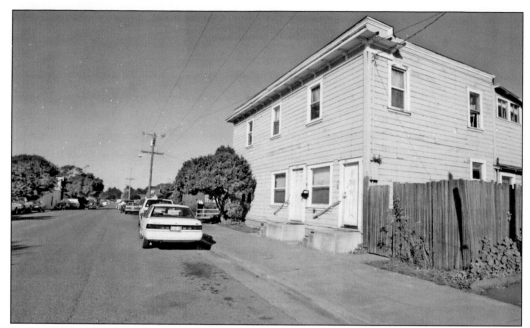

In the 1900s, the Chinese were allowed to live in Fort Bragg and actually developed a small Chinatown in the three-block area from Oak Street to Laurel Street and from McPherson Street to Harrison Street. Pictured here is Fort Bragg Chinatown's west-end boundary on McPherson Street. This building was once a Chinese store located on the east side of McPherson Street. Today it is broken up into apartments. (Photograph by Jeff Kan Lee.)

The south end of Redwood Avenue, shown here, was once the southern boundary of Chinatown east of Highway 1. Today these buildings are a collection of businesses, offices, and apartments. (Photograph by Jeff Kan Lee.)

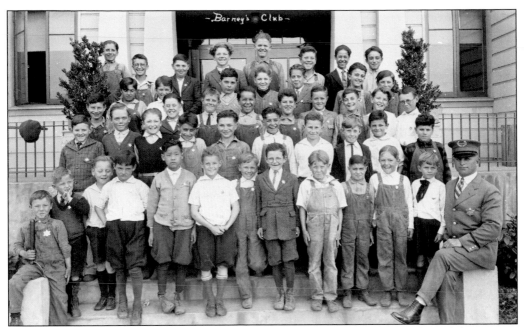

In 1926, this unidentified Chinese boy (first row, center left) was a member of the Barney Club, a youth league that organized amateur boxing. (Courtesy MCM, Wonacott photograph, 83-27-0105.)

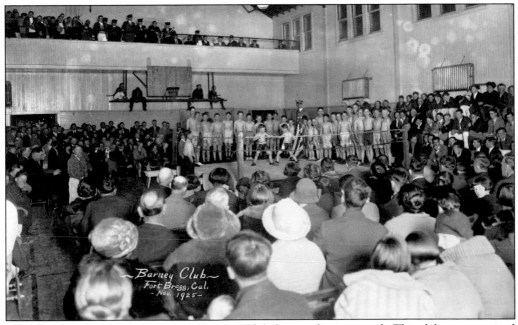

This photograph was taken inside the Barney Club during a boxing match. This club was organized for the young boys in the community. (Courtesy MCM, 83-27-108.)

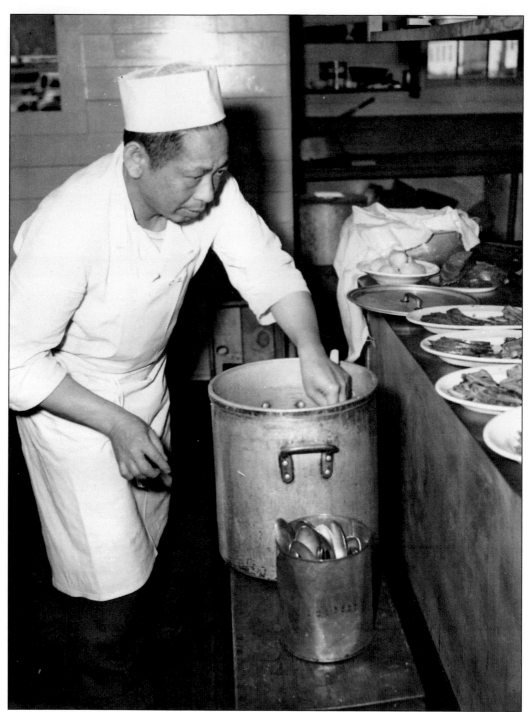

Some of the Union Lumber Company's lumber was cut on the outskirts of the city limits in the area known as Ten Mile. Camp No. 2 at Ten Mile was built to house the woods crew. It was a small community in itself that included cabins for single men, showers, toilet facilities, and a cookhouse that included a galley mess hall. Pictured here is Henry Choy, the head cook. (Courtesy FBMCHS, CNTF3-F180.)

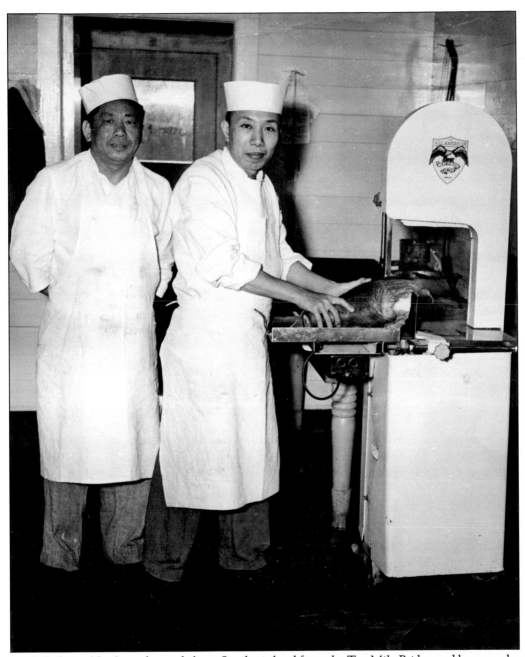

In 1949, Camp No. 2 was located about 5 miles inland from the Ten Mile Bridge and became the headquarters for the Ten Mile logging operation. The camp was upgraded with a modern kitchen. The lumber company hired head cook Henry Choy and assistant cook Kai Kwan Wong. The galley was equipped with a walk-in cold storage box, modern potato peeler, and an electric meat saw. According to *Noyo Chief* magazine, the Camp No. 2 cookhouse closed in 1952. Henry Choy and Kai Kwan Wong went back to San Francisco to work. Shown here from left to right are head cook Henry Choy and Kai Kwan Wong at Camp No. 2 showing off their brand new meat slicer. (Courtesy FBMCHS, CTNF3-F179-4.)

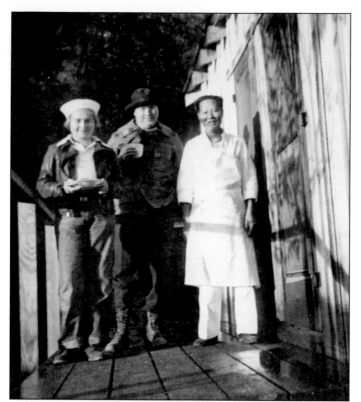

This unidentified Chinese cook worked at Camp No. 2. The person in the middle is John Hurley, and the person on the left is unidentified. (Courtesy FBMCHS, CTN3F179-01.)

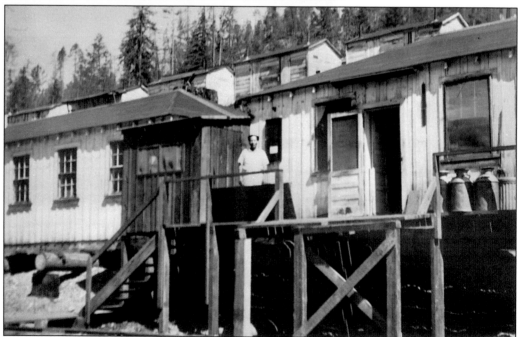

Here is another Chinese cook at Camp No. 2 at Ten Mile. Pictured above is Jim Tom, the head cook. This is the back porch of the kitchen that was built for the camp. (Courtesy FBMC, Union Lumber Company Collection.)

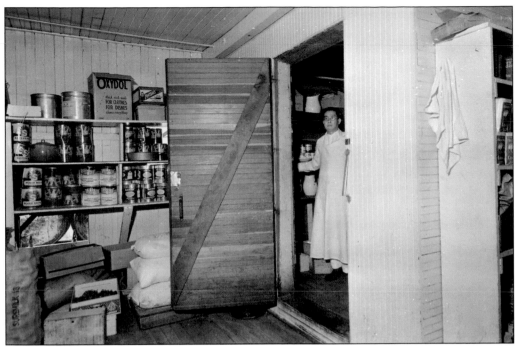

This is the "cold box" at Camp No. 2. The cold box was powered with electricity. The walk-in cold box allowed a large supply of fresh meats and vegetables to be kept on hand. (Courtesy FBMCHS, CTN3F179-03.)

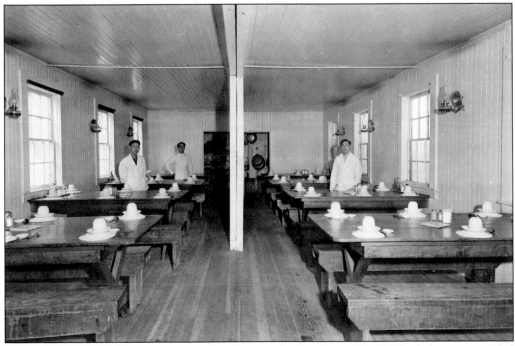

Shown here are the Chinese personnel in the mess hall at Camp No. 2. The light was provided by the oil lamps above the tables, later replaced with electric lights. (Courtesy FBMCHS, CNT3-F179-02.)

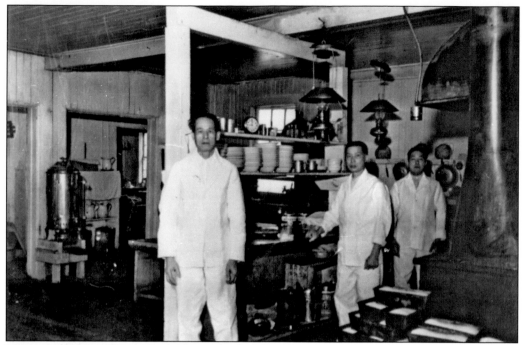

This is the galley at Camp No. 2. Notice the fresh bread in the right hand corner of the photograph. (Courtesy FBMCHS.)

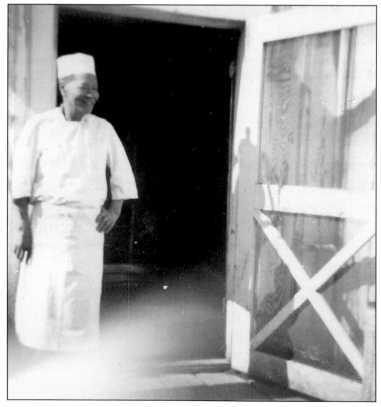

Jim Tom, a cook at Camp No. 2, stands in the doorway. (Courtesy Gloria Letner.)

Pictured here again is Camp No. 2 cook Jim Tom, holding an animal of some kind. This may have been a pet; it wasn't for a meal. (Courtesy Gloria Letner.)

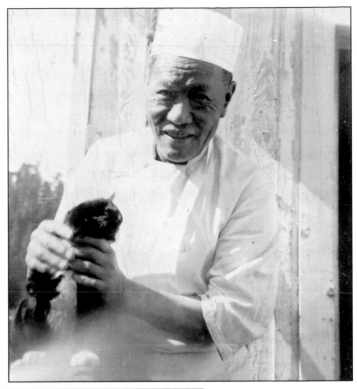

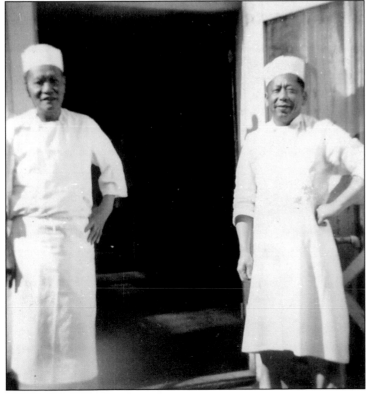

Henry Choy and Jim Tom (right) are pictured here, both Chinese cooks at Camp No. 2. (Courtesy Gloria Letner.)

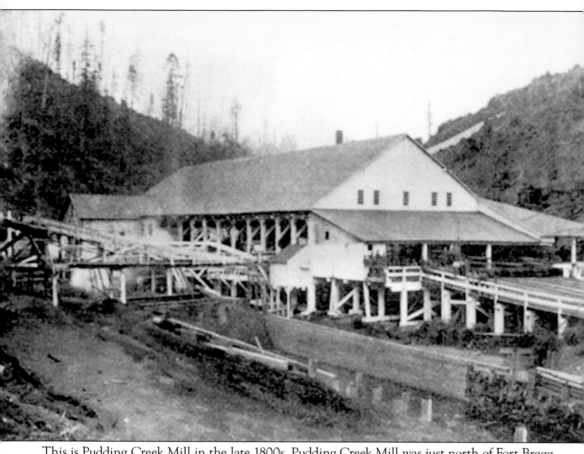

This is Pudding Creek Mill in the late 1800s. Pudding Creek Mill was just north of Fort Bragg. This structure is no longer here. (Courtesy FBMCHS.)

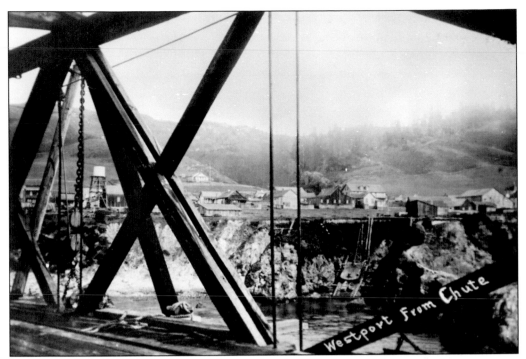

It is noted throughout the Fort Bragg *Advocate* that, in 1892, the anti-Chinese sentiment was very strong in the Westport-Rockport area. On August 16, 1893, the paper stated, "The last Chinaman has been deported." That year, when there were many unemployed white men, Rockport went as far as burning the Chinese quarters down to let them know they were not welcome. The Chinese history for this part of the coastal county is still not talked about. The few photographs shown in this section are the only evidence. This is a view of Westport from the chute of Westport Mill in the late 1800s. (Courtesy MCM, Escola Collection, 2000-14, Bdr 56 2455.)

This is the Rockport Mill, north of Westport. This was one of the many mills built in Rockport. The mills processed logs from the surrounding area and later produced redwood shingles. (Courtesy MCM, 2000-14, Bdr 34 1509.)

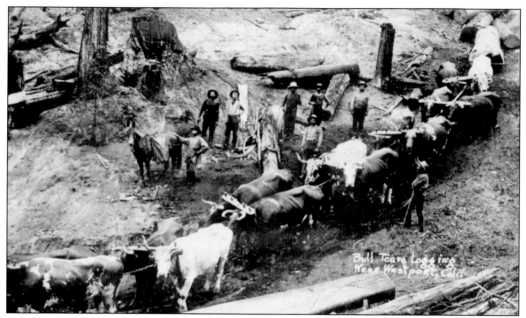

A bull team is shown here at Wages Creek, which is also north of Westport. This bull team also used Chinese laborers to help move the logs down the hills. (Courtesy MCHS, Escola Collection, No. 3066.)

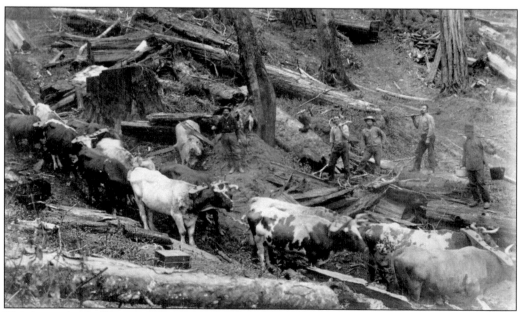

This is another bull team at Wages Creek. This photograph shows a Chinese water slinger on the right.(Courtesy MCM, Escola Collection, Carpenter photograph, 98-24-24.)

Three

TEMPLE OF KWAN TAI

The temple of Kwan Tai is the oldest original Chinese Taoist temple left on the North Coast. The temple was built about 1854 by the first Chinese settlers, including Joe Lee, the author's great-grandfather, giving the Chinese a place to practice their Taoist religion.

The temple is painted red, which represents joy and good luck, and trimmed with green, which represents life and prosperity. Inside the temple are two altars. The first altar holds dishes in which food is placed for our ancestors. The main altar holds a picture of the god Kwan Tai on the center back wall of the temple. There are benches on the east and west walls. The temple houses the god Kwan Tai, also called Kwan Ti, Guandi, Guangong, and Guan Yu. He is known as the god of literature, wealth, business, and social harmony, even though in most Western books he is associated with war. The gods of Taoism were once human beings who displayed exemplary qualities when alive. Upon their deaths, they were deified. The author will refer to the god in this temple as Kwan Tai, as was taught by her father. In her travels to Hong Kong, she learned that Kwan Tai was taught in the school system, and it was stressed that he was extremely loyal and very protective. According to Jonathan Lee, a doctorate student who has researched the various gods in Chinese culture, the governors in China called for volunteers in 184 CE to fight against the army known as the Yellow Turbans. This group of men that wore yellow turbans believed in the eminent beginning of the new world. They believed the "blue heaven" of the Han Dynasty was dead and the "yellow heaven" of great peace was at hand. This was a huge rebellion, with 360,000 men marching in China. During this time, Kwan Tai, Liu Bei, and Zhang Fe happened to meet and discovered they shared the same purpose. They became blood brothers, pledging loyalty to one another. They joined the Yellow Turbans and fought the Han regime. Kwan Tai proved himself to his countrymen with his sword, Black Dragon, and his horse, Red Hare. Therefore, he is worshiped for his might and his embodiment of "right action," of integrity, bravery, righteousness, and loyalty.

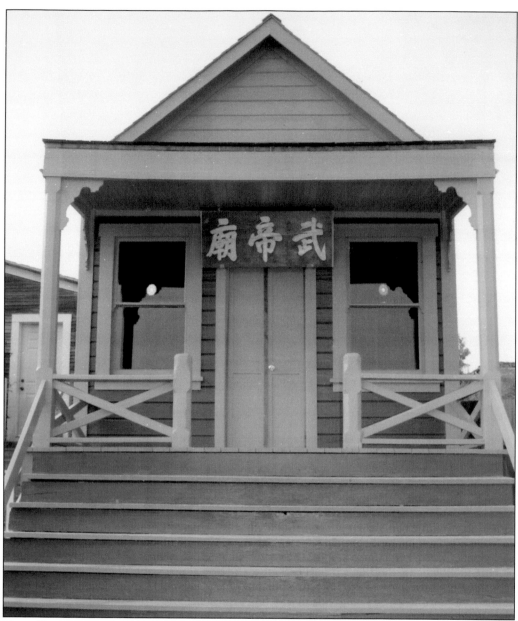

Kwan Tai was seen to personify integrity. He was elevated to a duke and eventually a god. Kwan Tai is known as a protector from all forms of evil, and his deification was based on these traits. Most Chinese who migrated from China in the 1800s practiced Taoism or Daoism. Taoism originated in China, and Laozi, the philosopher who authored *The Book of the Way*, is credited as its founder. Taoism offered an alternative to the Confucian way of life. It is said that the two religions, Confucianism and Taoism, are not mutually exclusive but complementary. Taoists believe that spirits are present in all aspects of nature. Offerings are made on the 1st and 15th of every month and on the new moons. The Chinese would gather on these dates every month. Chinese New Year was celebrated as a whole community. Offerings of food and beverages were made to Kwan Tai and each family's ancestors. Incense was lit every day to keep the spirits alive. (Courtesy Hee family collection.)

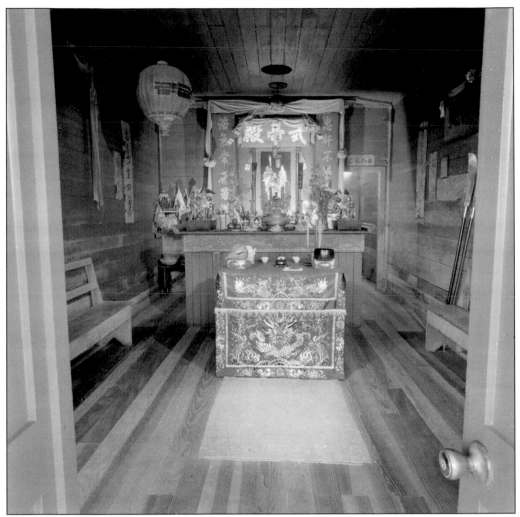

The temple was enlarged in the early 1870s. By mid-1870s, the temple had a full-time priest on the premises and would remain open 24 hours a day for the Chinese community. No Caucasians were allowed inside the temple, as the temple was the Chinese community's only sacred place. When Francis Nichols was a young boy, he mentioned that the author's grandmother, Yip Lee, "would not allow him in." However, she would allow the author's mother, who was Caucasian and a Southern Baptist, to enter the temple and join in the rites. The foods eaten for Chinese New Year were first taken to the temple to be blessed. When the author and her siblings were children, their parents would boil a freshly killed chicken and take it to the temple with other dishes prepared for the celebration, leaving them in the temple to be blessed. They would also leave rice, tea, fruit, nuts, candy, and wine for Kwan Tai and the family's ancestors. Incense was lit, money paper (which has gold or silver squares in the middle symbolizing money) was burned, and a prayer was said to insure prosperity in the future and to ask for a blessing from Kwan Tai. Taoists believe that if they do not do this, they will have bad luck in the upcoming year. The author's family still practices these rites. (Courtesy Hee family collection.)

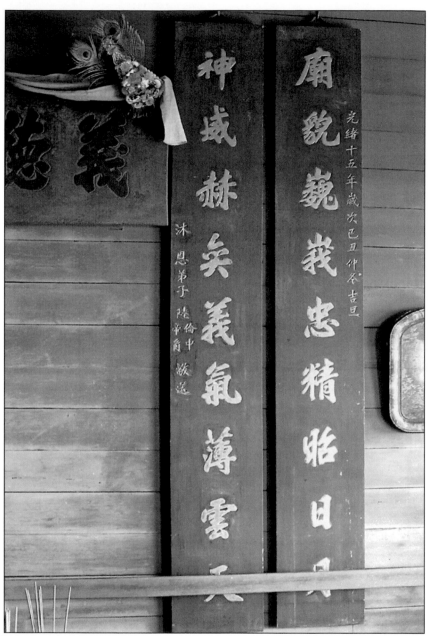

The author's family takes the blessed food home and eats it in celebration. New offerings are made on the 1st and 15th of every month. On the death anniversary of loved ones, incense is lit and offerings are made. Even today, traditional Chinese will have an altar to their god in their home where they will say prayers, burn incense, and make offerings. The temple was in the Hee family until the early 1990s. It was then donated to a newly formed nonprofit corporation that would continue to save and protect the temple in perpetuity. Several of the George Hee children donated their shares of the property to the nonprofit that was established on behalf of the temple, and the nonprofit corporation bought the remaining two sibling's shares. The corporation now owns the property and is continually educating the public about the temple's history and the Chinese people's role in Mendocino history. (Courtesy Hee family collection.)

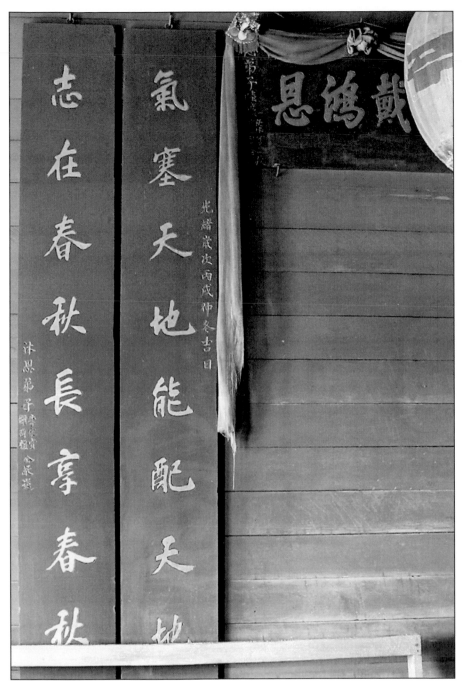

The signboards shown on the inside temple walls here and in the previous photograph were donated by the two main Chinese families in Mendocino, the Lee family and the Look family. The Look family has a signboard on the east wall and one on the west wall. The sayings on the east wall are from the Ching dynasty and, loosely translated, say, "your name will last forever." The boards are carved with the donating family name in small characters. The other boards are on the west wall and were donated by the Lees. A clear translation was not available. The author's family name is in the small characters on the sides of the boards. (Courtesy Hee family collection.)

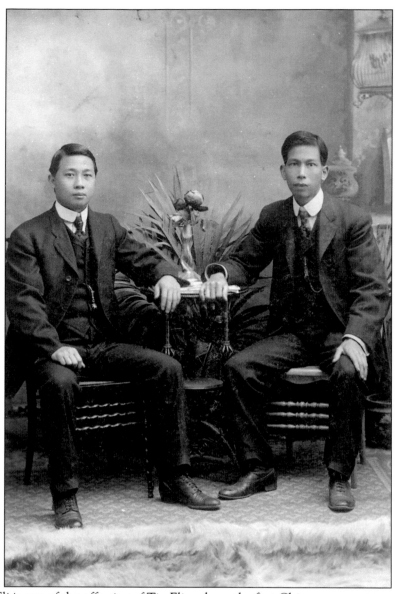

Look Tin Eli is one of the offspring of Tin Eli and was the first Chinese person to graduate from Mendocino High School. He went on to achieve much success in San Francisco. He founded the Bank of Canton in San Francisco and was responsible for rebuilding San Francisco's Chinatown after the 1906 earthquake. The saying "local boy makes good" certainly applies to Look Tin Eli. A letter written to Daisy MacCallum in 1927 from N. C. Brunner, the daughter of the former Chinese school teacher in Mendocino, says, "I think I mentioned in my former letters that most of the sons of Mendocino's old-time Chinese have shed some luster on the place of their activity. It seems remarkable, too, when we consider that every blessed one of these boys has made his own way in the world. For surely none of them inherited anything from his parents, for all of them poor, hard working men. Tin Eli, through his own efforts arose to the presidency of both a bank and a steamship company. While his brother, Lee Eli, became the head of another bank, and has accumulated a private fortune of least a couple of million dollars." Pictured here are Look Tin Eli (left) and his brother, Lee Eli. (Courtesy Kelley House Museum.)

Four

WONG FAMILY

The birth of artist Grace Hudson in 1865 was the beginning of a blessing for the promotion of diversity. She was known throughout her lifetime for her generosity and kindness to the Pomo Indians in Ukiah. Grace Hudson and her husband, John, employed Soon Quong Wong as their cook. Wong had four children, all born in China, while in their employment. Wong had a wife in China and would visit her often over the years. His children were Koon, Loon, Ngoon, and Harry. Harry, the youngest, had six children: Mark, Melissa, Paul, Glen, Dayle, and Kevin. Harry named his first son after Mark Carpenter, nephew to Grace, and his first daughter after Mark's wife, Melissa Carpenter. Grace was a devoted friend to her employee and his family members, and the feeling was mutual. Sadly, this friendship is not commonly known. Correspondence written over the years to Grace Hudson from Wong and his sons appears in the following pages. The letters talked about life in new environments and their illnesses over a seven year-period. The letters and photographs are a small sample of the Wongs' history.

12442a

April 12, 1935
Hong Kong, China

Dear Mr & Mrs. Hudson:

Arrived in Hong Kong yesterday morning. The trip was fairly pleasant although the water was pretty rough at times, but I did not get very sick. I went ashore at Honolulu and had a wonderful time there also at Shanghai. The weather is fairly warm here now and I am enjoying my good fortune. Well so long. I wish you the best of luck. I will write to you again soon.

Sincerely yours,

Harry.

P.S. Will you please tell the boy to take the two Chinese letters to Mr. Leng and one to laundry. Thank you.

This is a letter to Grace Hudson and her husband, John, from their cook, Soon Quong Wong, written in 1935, when he was visiting Hong Kong. This letter is one of many that Wong wrote from Hong Kong. Wong still had family, as well as a wife, in China. (Courtesy GHM, 12442a.)

Telephone Lackawanna 6668 Marigold Restaurant Corporation
12647a

PALAIS D'OR
Broadway at 48th St. New York

March 11, 1930

Dear Mrs Hudson,

Your wonderful "Christmas" "gift" are received. I am very sorry that I don't write to you sooner. the policeman are perfect for my little automobile I want to thanks you so much for send me that.

My younger brother stay with my older brother his going to school now.

Will Mrs. Hudson how's everything in Ukiah now. the business in New York are very slow. Please give best to Dr. Hudson & all you friend

Sincerely your,
Robert Wong

P S Please write to me if you have time.

This letter was written in 1930 by Wong's grandson Robert. It thanks Grace Hudson for his Christmas gift. (Courtesy GHM, 12647a.)

This is a letter written by Koon Wong, one of Wong's sons, from Sun Chong, China, to Grace Hudson. In the letter, he describes his trip to Hong Kong and many of the sights he has seen. He seems to be shopping for a god figurine that Grace Hudson asked for. (Courtesy GHM, 12465a.)

12465a

Sun Chong China
Oct. 14th, 1931

Dear Mrs Hudson!

Just returned from Canton City and Hong Kong on a vacation trip had plenty of good time and enjoy every minutes.

I saw some Gods, Two of it made out brass But its only a foot high; surely it is too small for the fountain!

There is is another one about three feet high, but it is made out of earth and burned afterward I don't know whether it can stand the rain or not, I am still looking for them

I am senting you a photograph of some lady, "See what are you think of her"?

Has Ngoon get a job?

Love to all and from all.

Sincerely
Koon

12605a

Dec 3 1931

mrs J.W Hudson I send up two doller to you please you tell Dr Hudson my medecine send to me

form Ngoon Wong

This 1931 letter was written by another of Wong's sons, Ngoon. It is a short letter that contained two dollars to pay Grace Hudson's husband, John, for some medication. (Courtesy GHM, 12605a.)

June 15 1932

Mrs Hudson I am go up
Willits to see mrs. Van I
am ask him get me job he
She will you come back
Wedneday to see me again
I am take Walking up Willits
She till me look for him
paid Me $500 dollar month
will I ask mrs Konight get job
to Lun Lung he she Bung mela to
young dont know how
book
From Ngoon Wong

Ngoon Wong wrote this letter in 1932 to Grace Hudson describing his journey seeking employment in Willits. (Courtesy GHM, 12608.)

Minneapolis Minn.
Dec. 6, 1933.

Dear Mrs Hudson,

I am just send you a taste of Mun Hing's famous noodles, Which has its reputation through the Northwest. and thinking sending some of the canned chow mein, for I know the Western people won't en even think of taste of such thing, Which the folks are crazy about in here.

Lung and Lun is about reach home by now I bet the family are glad to see them.

How is Uncle John and rest of the family?

Love to all.

Koon Wong

This is a 1933 letter written by Koon Wong from Minneapolis talking about how much the people in the east love Mun Hing's famous noodles. He enclosed some of the chow mein for Grace Hudson to taste. This may be one of the first acknowledgments of commercialized chow mein. (Courtesy GHM, 2481a.)

This letter arrived from Chew On Village in Canton, China, in 1934. The letter is from Loon, another son of Wong's. The letter describes his efforts to go to school and requests some medication for his stomach from John Hudson, Grace Hudson's husband. (Courtesy GHM, 12439a.)

12439a

March 15, 1934
Chew On Village
Canton China

Dear Mrs Hudson;
Received your letter last month, also had one from Loon and a bundle of paper, you mail me the paper about Ring accident but I did relieved,
Mother told you not to get a bicycle for Ding because she hes so many accident about the China the boy. I can't go to school because they had so many people in one classe or the have to get a sester teacher,
The other day I have hear some new about the people just rubber everything they get in minneapolis. Is that truth?
Please send me a box of pal for my indigestion stomach.
With my love do all.
Sincerely your,
Loon Wong.

July 31, 1935.
Hoi San Ho King
Canton

Dear Mr & Mrs. Hudson: 12445a

I received you letter today, and understood what is all about. I'm glad to know what you all are doing there, but I'm very sorry to know you has lost ten pounds since I came home.

When I came home, my family are very glad. I'm very busy now, the old house is leaked every where, last month we started to tears it down and rebuild it.

I'm to hear that Ding is getting along fine. I hope you will keep him busy and back him.
Loon will be back when the house is finish.
I'll write to you again sometime, I hope you all have a good time and wish you all good health. Sincerely yours.
Wong

This is another letter from Canton, China, dated 1935. The letter is from Wong and describes how happy his family was to see him. It appears he returned to help the family fix their house. (Courtesy GHM, 12445a.)

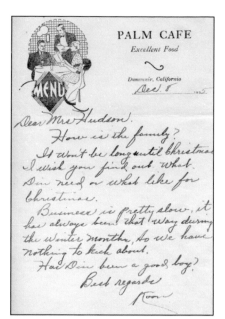

This is a 1935 letter from Koon Wong written from Dunsmuir, California. The letter asks Grace Hudson what she thinks Din, his cousin, would like for Christmas. (Courtesy GHM, 12489a.)

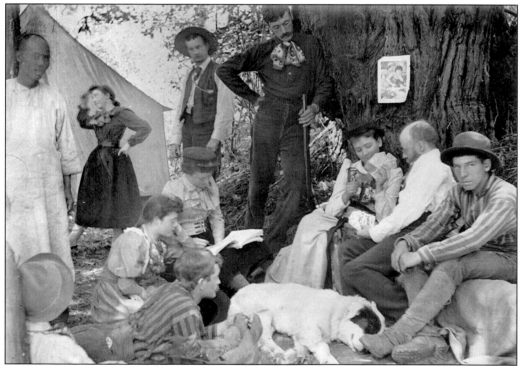

The author was fortunate enough to be able to look at Grace Hudson's albums, including one that documented the Wong children from their early years to the births of their own children. After the death of Grace Hudson in 1937, her twin brother's son, Mark Carpenter, and his wife, Melissa Carpenter, inherited the Hudson estate. They also continued the close relationship with Wong's children, as seen in the various pictures of their families. Here are Grace and John Hudson at Honeymoon Camp with their Chinese cook and friends. Grace is sitting against the tree with her husband John at right. The others are unidentified. (Courtesy GHM, 17217.)

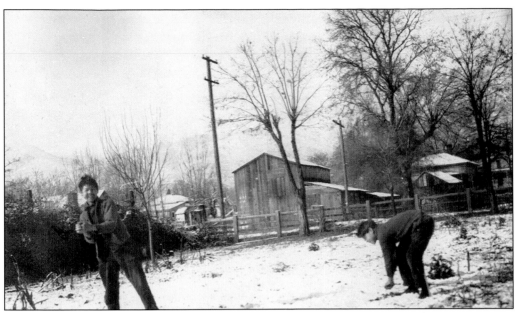

Pictured here are Ngoon and Koon Wong as young boys playing on Grace Hudson's property in Ukiah. (Courtesy GHM, 18928.)

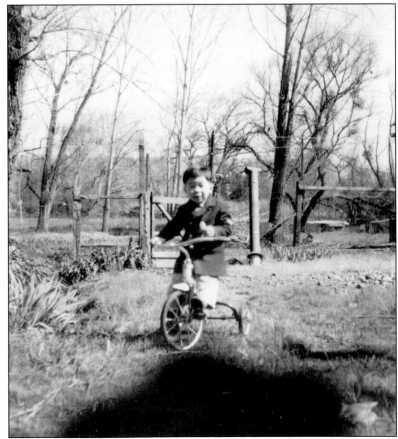

This is Mark Wong on a tricycle on the Hudsons' property. (Courtesy GHM, 17900F.)

Pictured in the middle of the back row is another of Wong's sons. He was in the fifth grade in 1921 in Ukiah. (Courtesy GHM, 17908B.)

Shown here is Soon Quong Wong, father of the Wong children, in 1920. (Courtesy GHM, Grace Hudson's personal photograph album, 18928.)

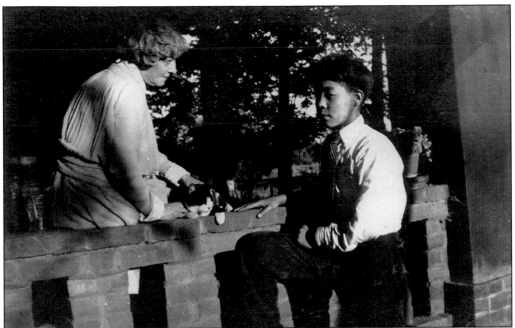

Koon Wong and Grace Hudson are pictured here on the Sun House porch in 1921. The Sun House was Grace and John Hudson's residence. (Courtesy GHM, Grace Hudson's personal photograph album, 18928.)

Ngoon Wong is shown here in 1922 in front of the Sun House steps. He appears to be sweeping the steps. (Courtesy GHM, Grace Hudson's personal photograph album, 18928.)

In 1922, Grace Hudson and Ngoon Wong sit on the Sun House steps. She appears to be demonstrating something to him. (Courtesy GHM, Grace Hudson's personal photograph album, 18928.)

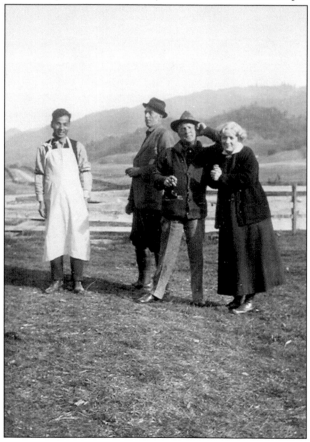

John and Grace Hudson are pictured here at Potter Valley with Soon Quong Wong. The photograph was taken on Thanksgiving Day in 1922. (Courtesy GHM, 18016.)

In 1924, Soon Wong is again pictured at Potter Valley. He appears to be harvesting fruit from the tree. (Courtesy GHM, Grace Hudson's personal photograph album, 18928.)

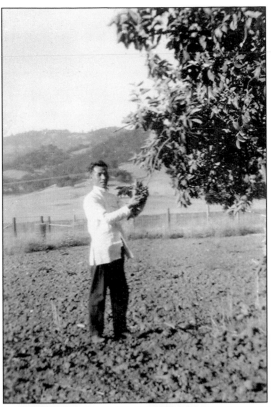

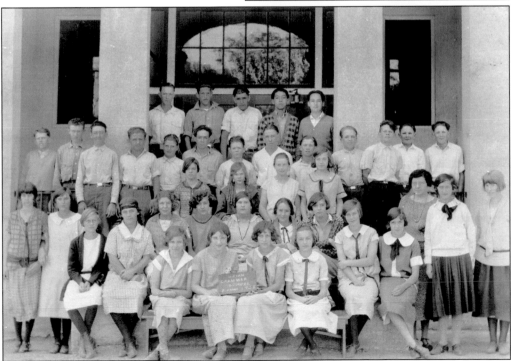

Koon Wong is pictured in the back with his class in 1925. (Courtesy GHM, 17908F.)

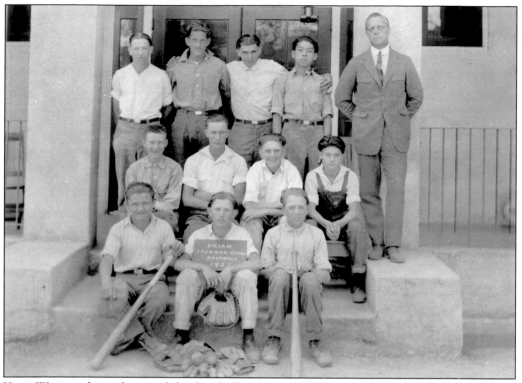

Koon Wong is shown here with his baseball team in 1925. (Courtesy GHM, 17908H.)

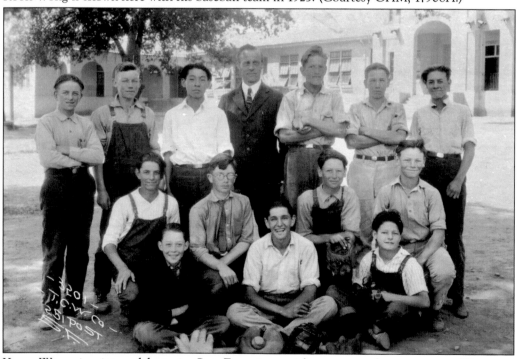

Koon Wong is pictured here in San Francisco with a group of young men. (Courtesy GHM, 17908E.)

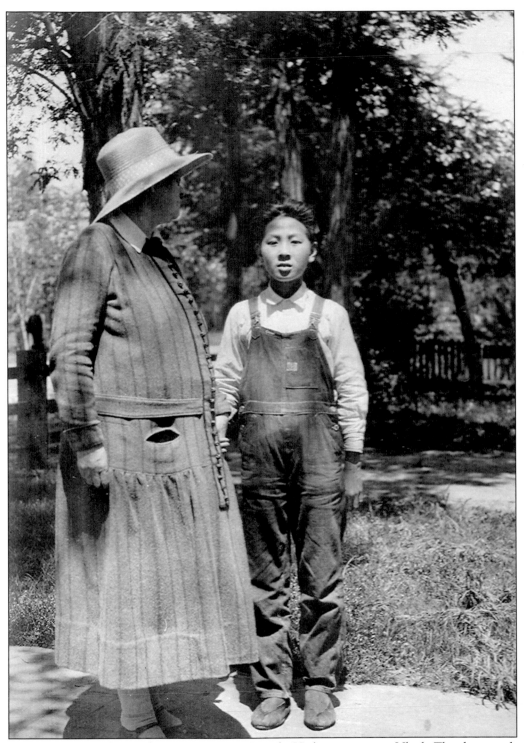

Here are Grace Hudson and Loon Wong in 1927 on the Hudson property in Ukiah. The photograph was taken 10 years before Grace Hudson died. (Courtesy GHM, Grace Hudson's personal photograph album, 18928.)

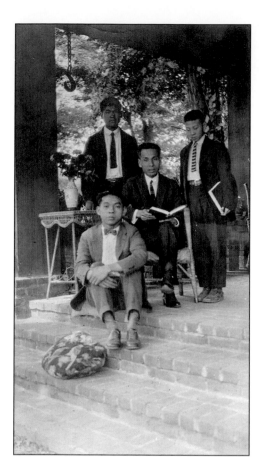

Wong and three of his sons are pictured here in 1927. They are on the porch of Grace and John Hudson. (Courtesy GHM, Grace Hudson's personal photograph album, 18928.)

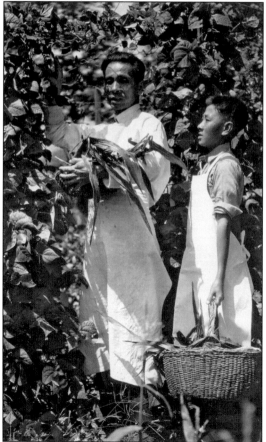

Wong and Loon are shown here in the garden in 1927. (Courtesy GHM, Grace Hudson's personal photograph album, 18928.)

In 1929, one of Wong's sons was in the fourth grade in Ukiah. He is pictured in the top left in the dark sweater. (Courtesy GHM, 17908A.)

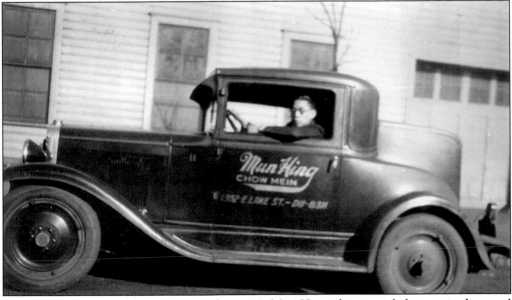

Koon Wong is pictured here in a car advertising Mun Hing, the canned chow mein discussed earlier in one of his letters to Grace Hudson. The photograph was taken in Minneapolis in August 1930. (Courtesy GHM, Grace Hudson's personal photograph album, 18928.)

This is Loon Wong with his sixth grade class in 1935. He is pictured in the middle of the back row. (Courtesy GHM, 17908G.)

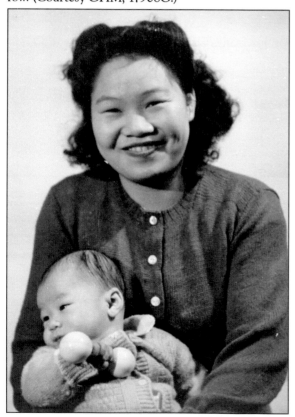

Harry Wong's wife, Nancy, and son Mark are pictured here in 1949. Harry was another of Soon Quong Wong's sons. (Courtesy GHM.)

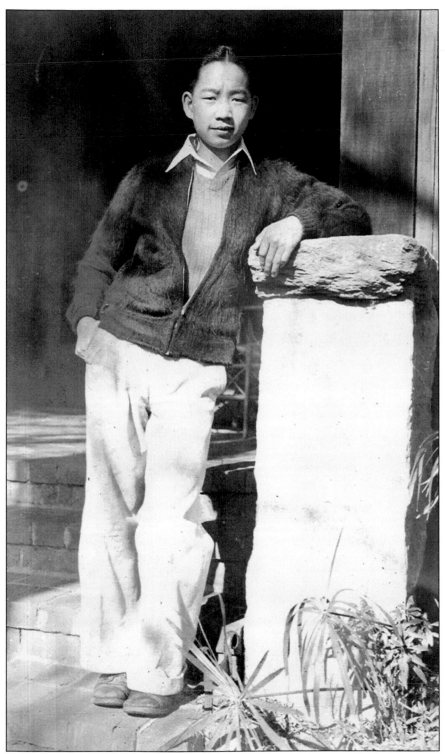

Ding Wong, from China, is a cousin who came to live with the Wongs in Ukiah. (Courtesy GHM, Grace Hudson's personal photograph album, 18928.)

Loon Wong is shown here. (Courtesy GHM, Grace Hudson's personal photograph album, 18928.)

Harry Wong is pictured in 1945 wearing his military uniform. He enlisted in the army in 1944. (Courtesy GHM, Hudson 17906a.)

Pictured here from left to right are Harry Wong's wife, Mark Carpenter with Mark Wong, and Harry Wong in 1940. Mark Carpenter later inherited Grace and John Hudson's estate. (Courtesy GHM, Hudson 17902b.)

Harry; his wife, Nancy; his son Mark; and daughter Melissa (in Nancy arm's) are pictured. Note the design carved in the side of the house. (Courtesy GHM, Hudson 17902a.)

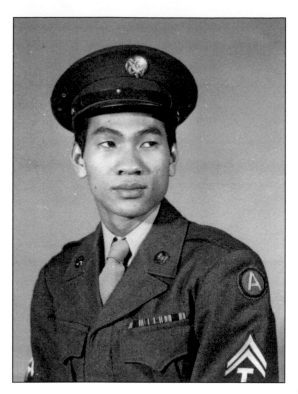

Harry Wong is shown in his army uniform in 1946. After leaving the military, Harry went to China and married his wife, Nancy, in 1948. (Courtesy GHM, Hudson 17906e.)

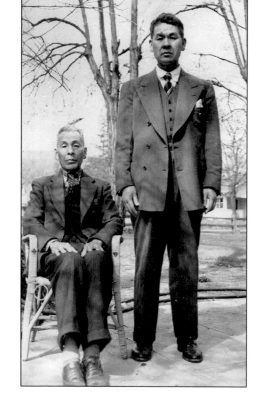

Here are Soon Quong Wong and his son Ngoon in 1947. Soon Quong Wong is seated. They are posing on Grace Hudson's property in Ukiah. (Courtesy GHM, Grace Hudson's personal photograph album, 18928.)

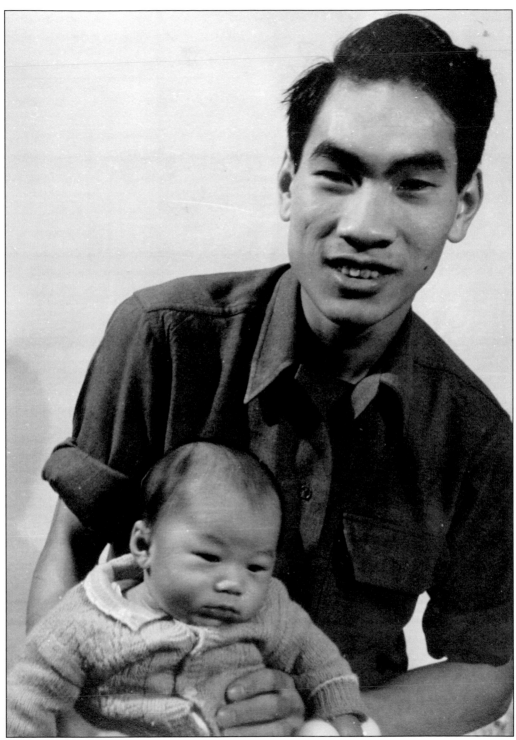

Harry Wong is shown holding his newborn child, Mark, in 1949. (Courtesy GHM.)

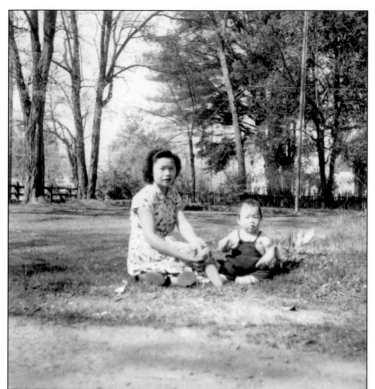

Harry Wong's wife, Nancy, and son Mark are pictured here in 1951 on Grace Hudson's property. (Courtesy GHM, 17901h.)

Harry's wife and their son Mark are shown once more in 1951. The picture is again taken on Grace's property. (Courtesy GHM, 17901a.)

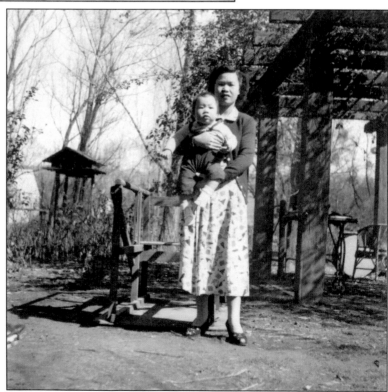

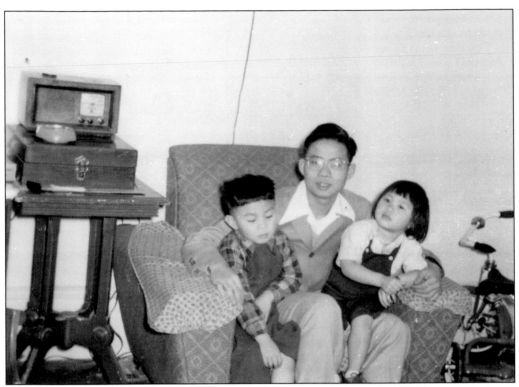

Here is William Wong, one of Soon Quong Wong's grandchildren, holding his son Carl and daughter Nancy in 1953. (Courtesy GHM, 17904a.)

This is Soon Quong Wong's granddaughter Melissa in 1959. Melissa Wong is the daughter of Frank Wong. She is still living. This picture was taken at Marion School in Novato. (Courtesy GHM, Grace Hudson's personal photograph album, 18928.)

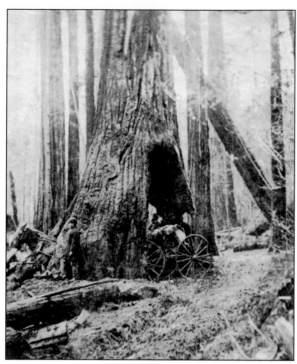

To travel to the coast, most had to take a carriage through large redwood groves like this one in the Willits area. This is a drive-through tree. Pictured are J. C. Ford in the wagon and J. B. Ford standing alongside the tree. (Courtesy MCM, 20000-14-464.)

An unidentified Chinese family stands on a fallen redwood tree. Note the size of the tree. (Courtesy MCM, Escola Collection, 2000-14, Bdr 55 1802.)

Five

LEE FAMILY

John Song Lee, also known as Joe Lee, was a farmer who heard about the California gold rush and decided he would go to make some money so that his family could have a better life back in China. The oral history in the family was that he went to the Philippines to receive some brief sailing lessons. Then, in the early 1850s, seven junks started out from China to sail to the Monterey Coast, where they would later make their way to the gold fields. Only two junks survived the journey over the Pacific Ocean. One landed in Monterey, but Joe Lee's got off course and landed at Caspar Beach, 5 miles north of Mendocino. The story has been authenticated by Stanford Lyman, who has interviewed surviving descendants in the Monterey area. Historically, it has been said that the Chinese were trading with the Native Americans long before the Spaniards discovered California. There have been many stories of researchers finding Chinese pottery in the Monterey Bay. At the time of great-grandfather Lee's arrival, the redwood lumber industry was blossoming, so there was a great demand for labor. According to a 1937 article in the *Mendocino Beacon*, Fong Sung Choy arrived from Monterey in 1862 by Pacific steamer and married Joe Lee. It is not clear what type of work Joe Lee did, but he and his wife remained in the area until the early 1900s. Joe Lee and Fong Sung Choy had two sons and two daughters: Lee Gum Yuen, known as Kim Lee; the author's grandmother, Lee Gum Yip, known as Ann Yip Lee; Lee Gum Hui, known as Gim Lee; and Kum Oy Lee. Another book refers to the children only by their Chinese names, but Edwin, the son of Gim, said they knew their father as Gim. Some written descriptions say Joe Lee returned to China in 1902 with his wife, Fong Sun Choy, and both died in China around 1904. However, these dates are not authenticated. Gim Lee had nine children. The eldest, Elsie, was born in 1916; Grace in 1917; Pearl in 1920; Alice in 1922; Bessie in 1923; Rose in 1925; Bert in 1927; Edwin in 1928; and Eva in 1930. Gim Lee, the author's great-uncle, died in 1939 and was buried in the San Francisco area.

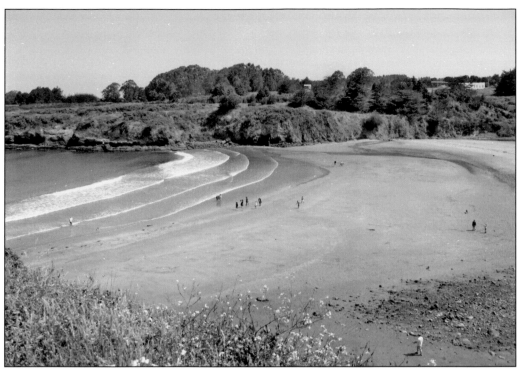

This is Caspar Beach, where the boat carrying the author's grandfather landed in the early 1850s. (Photograph by Jeff Kan Lee.)

Steamer "Sea Foam" taking on Passengers at Mendocino, Cal.

This is how passengers were loaded on the ships in Mendocino. (Courtesy Katy Tahja, Escola Collection.)

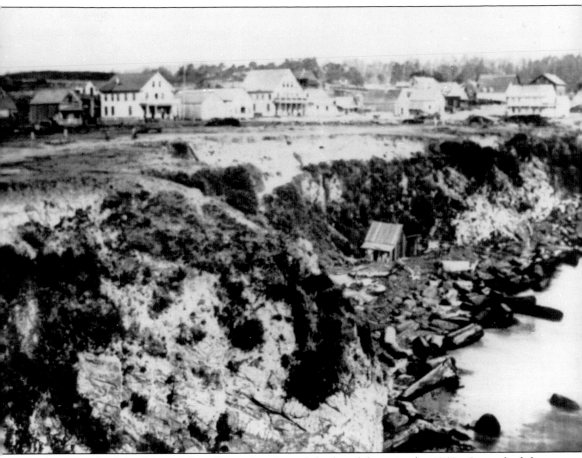

These are the Mendocino Main Street hotels and the beachfront in the 1860s. Several of the buildings on Main Street are still in use as commercial businesses. There are no longer buildings on the beach itself. (Courtesy Katy Tahja, Kelley House Collection.)

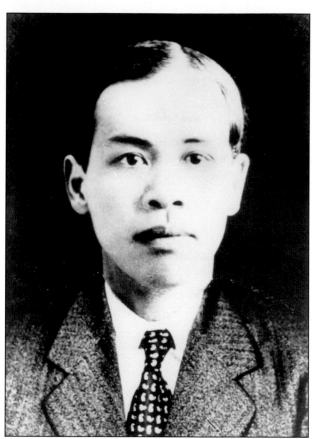

Pictured is Gim Lee, the author's great-uncle. Gim Lee was the son of Joe Lee. (Courtesy Denise Lee Lum, daughter of Edwin Lee.)

Shown from left to right in this 1929 photograph of Gim Lee's family are Pearl; Grace; Chin Mei Lan, Gim Lee's wife; Bert; Bessie; and Elsie. Gim Lee went to China to find his wife. (Courtesy Denise Lee.)

From left to right, these are Gim Lee's children Alice, Elsie holding Bert, Rose, and Pearl. Not pictured are Grace, Bessie, Edwin and Eva. The photograph was taken in 1929. (Courtesy Denise Lee.)

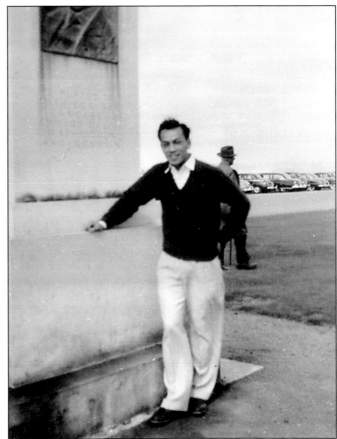

This is Edwin Lee, the youngest son of Gim Lee. The photograph was taken in Marin County in 1949. Edwin was meeting friends for a picnic. (Courtesy Denise Lee.)

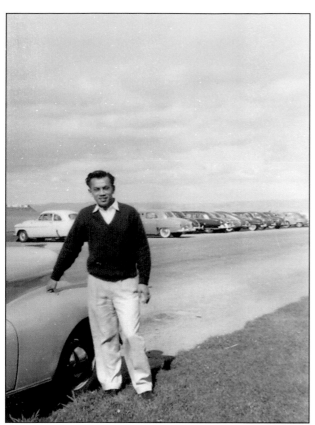

Edwin Lee is shown here once again in 1949. He is standing by his car in the parking lot in Marin County. Edwin was meeting friends to have a picnic. (Courtesy Denise Lee.)

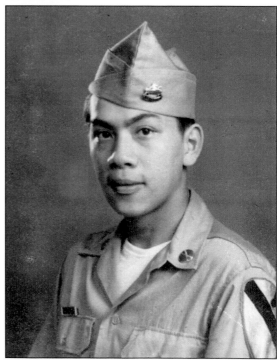

Edwin Lee is pictured in 1947 in his army uniform. Edwin served four years. (Courtesy Denise Lee.)

Six

HEE FAMILY

Yip Lee was born in Mendocino in 1875 on the west side of Albion Street on the property where the temple of Kwan Tai now stands. She married Chow Ah Hee, a cook in the Carlson Hotel who later became the proprietor of a restaurant in Mendocino City. The Hees have been asked many times if they can trace their ancestral history, but Ah Hee came to California at a time when it was no longer legal for any new Chinese to enter. The only exceptions were those related to a Chinese person who already resided in the state. Ah Hee paid such a person to state on paper that he was his son. The term for this is "paper son," meaning the person in question was related on paper only. The "paper son" took the name of the person who helped him, so it is almost impossible to follow the trail beyond this point. Yip and Ah Hee had 13 children, seven boys and six girls born between 1897 and 1916. Three children died in their early years. The remaining 10 children were William Hung Hee, Charles Tai Loy Hee, George Tai Sung Wilfred Hee, Elizabeth Quai Yung, Dewey Tai Bow Hee, Joseph Tai Foo Gilbert Hee, Edith Quai Lan Delight Hee, Grace Quai Linn Elaine Hee, Harold Tai Quong, and Mildred Quai Jun Alden Hee. In the 1920s, not long after Joe Lee returned to China, Ah Hee also returned, leaving Yip in Mendocino with the 10 children. Ah Hee died in China in 1924. By this time, there were not a lot of Chinese in Mendocino. Yip went to work as a housekeeper for Daisy MacCallum. It was Daisy's friendship that helped the author's grandmother survive in Mendocino. Yip Lee died in 1952 and was buried in the San Francisco area. All the photographs on the following pages are from the Hee family collection.

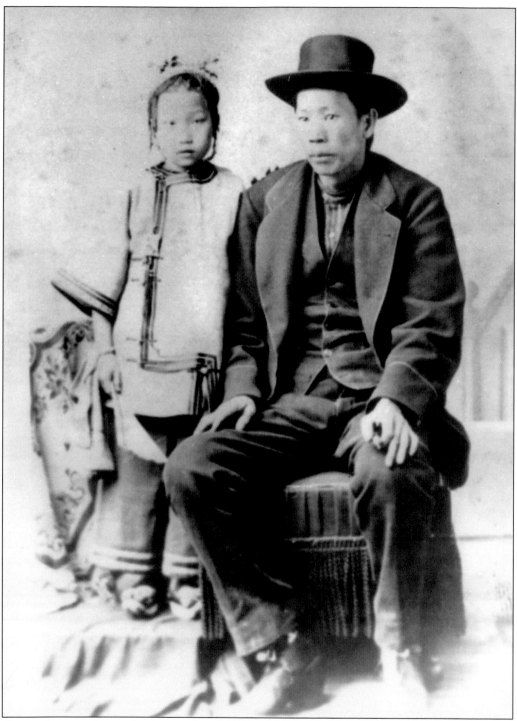

Shown here is the author's grandmother, Yip Lee, with her father, Joe Lee, the author's great-grandfather. (Courtesy Hee family collection.)

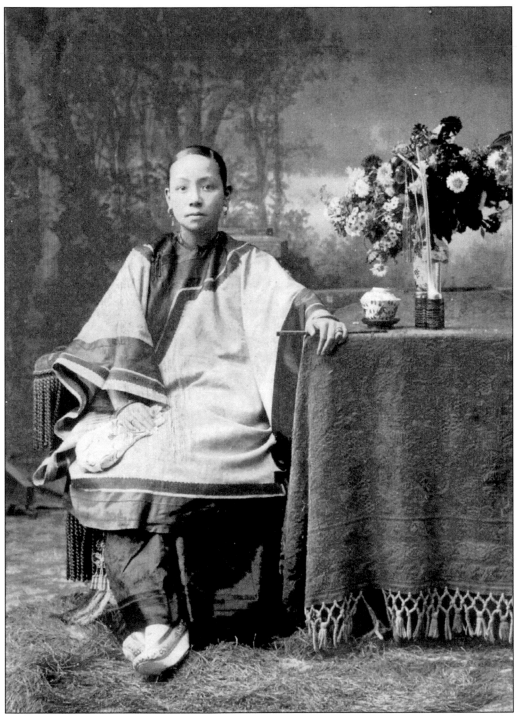

Yip Lee is shown here in later years. Please note her feet. According to the author's mother, Martha Hee, Yip's feet were bound when she was young. (Courtesy Hee family collection.)

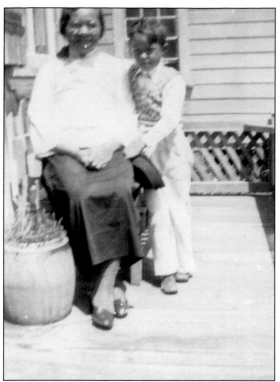

Here Yip Lee is pictured with her grandson Raymond Hee, the oldest son of George Hee. (Courtesy Hee family collection.)

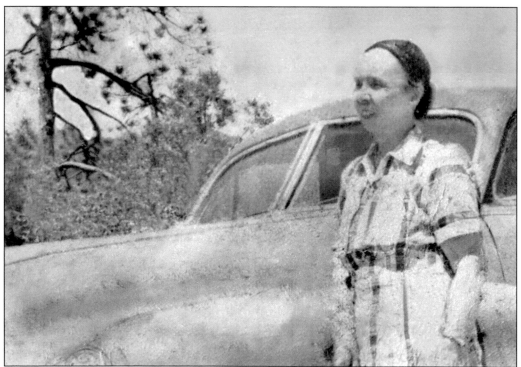

Yip Lee, the author's grandmother, appears here in her later years. (Courtesy Hee family collection.)

Daisy MacCallum's friendship gave the author's grandmother, Yip Lee, a veil of protection after her husband returned to China and left her with 10 children in the 1920s. Daisy MacCallum is pictured here in her younger years. She played a central role in the history of the town of Mendocino. (Courtesy Kelley House Museum.)

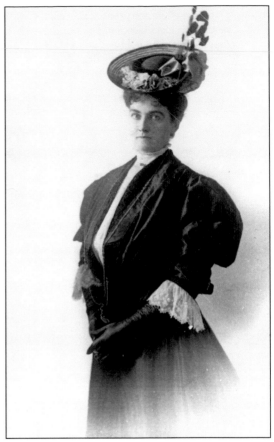

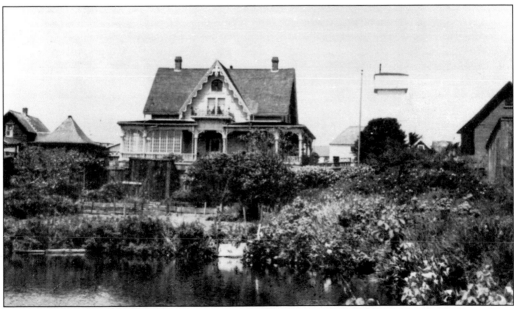

Daisy MacCallum's house, located in the center of town, is one of the historic homes still standing in Mendocino. The picture is from a postcard produced by the MCHS of Ukiah.

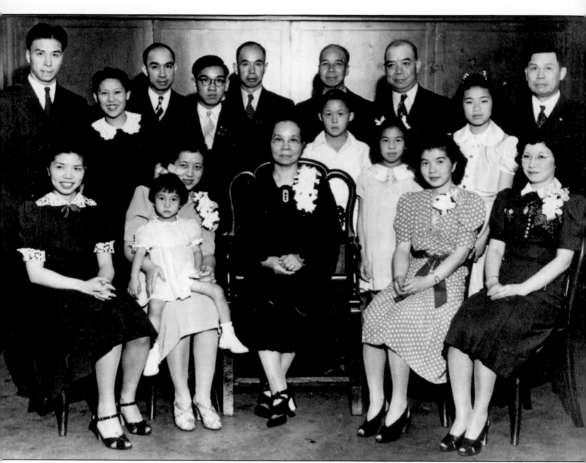

This is the last family picture of Yip Lee, taken on her 64th birthday. She is pictured with her children and other family members. From left to right are (first row) Grace, Edith with Judith, Yip, Mildred, and Elizabeth; (second row) Alice, Edward, Elizabeth's son William Jr., William's daughter Mary Ann, and Elizabeth's daughter Dorothy Quong; (third row) Harold, Joseph, George (the author's father), Charles, William, and George Quong (Elizabeth's husband). (Courtesy Hee family collection.)

This is the family burial site in Mendocino, also called the Chinese or Catholic cemetery. Per grandmother Hee's request, a Chinese priest selected the site based on the feng shui of the Taoist religion. The only remains left in the Chinese Cemetery are of the Hee family, because the others were exhumed. An article in the *Mendocino Beacon* on August 9, 1913, stated, "During the past week the remains of a number Chinese, which were interred in a local cemetery have been exhumed and will shortly be shipped to China. It is the custom of the Chinese when a native of China dies and is buried in a foreign land, to disinter the bones after a certain length of time and ship them back to the deceased's birthplace that all remains that is mortal of the dead Celestial may be at rest in the home of his ancestors in the Flowery Kingdom. . . . The jars will be shipped to China and there placed upon shelves in columbaria in different cities. Jack Toy, who is acting on behalf of the Ning Yung Company, one of the Chinese six companies of San Francisco, to which the deceased belonged. It is significant fact that all of these Chinese recently exhumed have been victims of accidents, not one having died from natural causes." (Courtesy Jeff Kan Lee.)

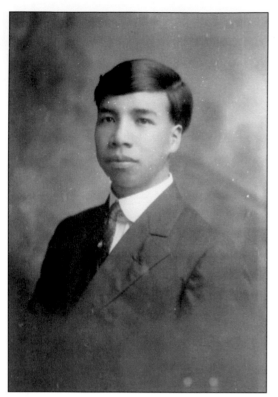

On August 1955, the magazine *Noyo Chief* featured an article about Charlie Hee, son of Yip Lee, as the old timer of the Union Lumber Company. Charlie Hee was a graduate of Mendocino High, and during his summer vacation, he went to work at the Boyle's camp waiting tables. After his graduation, he moved to San Francisco and worked as a shipping clerk for the Union Fish Company. He remained there for seven years and then returned to Mendocino. He worked at the Mendocino Mill until it closed and then transferred to the Union Lumber Company to scale logs on the log deck. Charlie never married and died on July 3, 1969. Charles (Charlie) Hee, son of Yip Lee and brother to the author's father, George, is shown here as a young man. (Courtesy Hee family collection.)

Charles Hee is pictured standing on Main Street in Mendocino is his later years. (Courtesy Hee family collection.)

On June 6, 1920, the *Mendocino Beacon* describes the wedding of Lizzie Hee: "Miss Lizzie Hee, daughter of Mr. and Ah Hee, local Chinese residents of this place was married in San Francisco Wednesday to Ng Quong, a prosperous restaurant keeper of Los Angeles." The following was taken from the *San Francisco Examiner*: "In full evening dress, swallow-tails with white ties a la mode, although it was mid afternoon, bridegroom and best man stood up before the Rev. E. F. Hall, who is secretary of the Board of Foreign Missions. The bride, an unusually pretty girl almost American type, and a protégé of Miss Donaldina Cameron, was fashionably attired in American bridal gown and veil trimmed with orange blossoms. In contrast, at her left side stood her Chinese mother, in lieu of a bridesmaid. Thus modern conventionality made concession to ancient custom. Miss Hee was born and raised in this place, as was her mother, although the latter clings to Chinese customs and the Chinese dress. The bride graduated from both the local grammar and high schools. Recently she has been clerking in her brother's store." This is a photograph of Elizabeth (Lizzie) Hee, one of Yip Lee's daughters and the sister of George Hee. (Courtesy Hee family collection.)

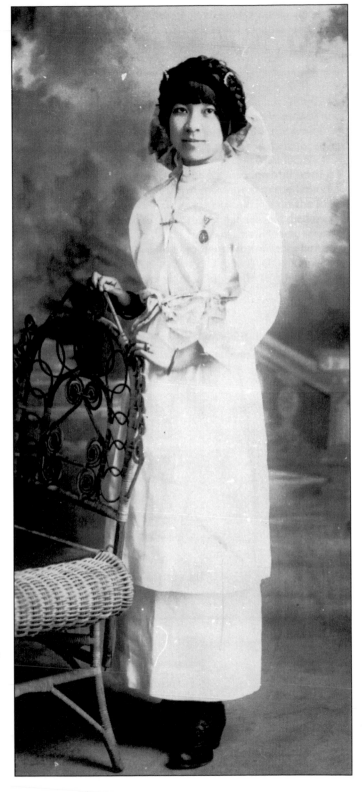

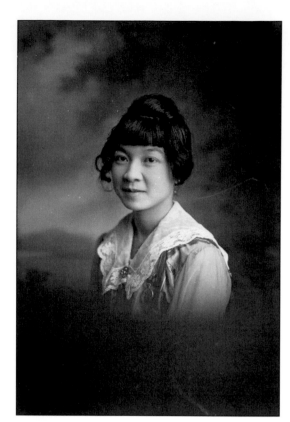

This is Elizabeth Hee as a young woman. (Courtesy Hee family collection.)

This is Edith Hee, another daughter of Yip Lee's and sister to the author's father, George. (Courtesy Hee family collection.)

Here again is Edith Hee on the family property on Main Street. (Courtesy Hee family collection.)

This is Dewey Hee, son of Yip Lee and the brother of George Hee. Dewey died at a young age in an automobile accident on Comptche/Ukiah Road in 1928. (Courtesy Hee family collection.)

This is Grace Hee, Yip Lee's daughter and George Hee's sister. (Courtesy Hee family collection.)

Shown here is Mildred Hee with her daughter, Janice. She is the wife of Harold Hee, Yip Lee's son. (Courtesy Hee family collection.)

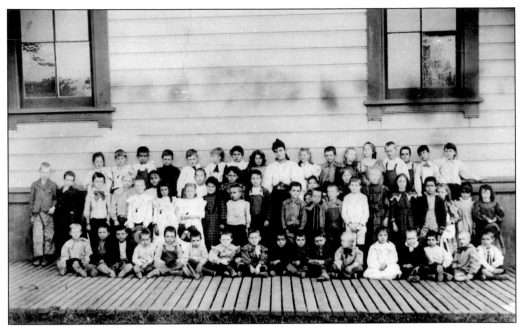

One of Yip Lee's children is shown here with his Mendocino Grammar School class (third row, fifth from the left) in 1910. (Courtesy MCM.)

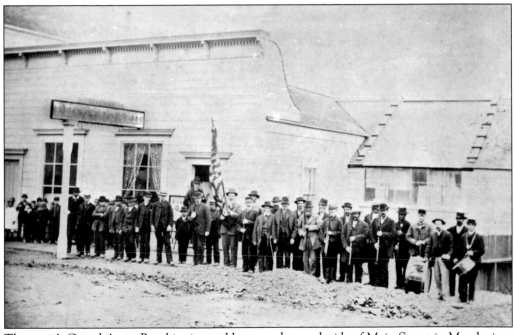

The town's Grand Army Band is pictured here on the south side of Main Street in Mendocino. (Courtesy MCM, Escola Collection.)

Three of Yip Lee's sons are shown here at Big River around 1960. From left to right are George, Harold, and Charlie. (Courtesy Hee family collection.)

Pictured is a family outing at Big River in the 1960s when the author's uncle Harold was visiting. From left to right are (first row) Wesley, Mervin, Lorraine, and Dewey; (second row) George, Charlie, Dennis, and Jeffery Hee. The children in the front row are George Hee's. (Courtesy Hee family collection.)

In the early days, when George Hee had to travel to San Francisco to visit family or take the author's brother, Dewey, to the Shriner's Hospital for Crippled Children, he stopped in San Francisco's Chinatown to stock up on supplies that were not available in Mendocino or Fort Bragg. The items purchased were the family's main ingredients in Chinese dishes. Long grain rice was not available locally, so George Hee would buy hundred-pound sacks and gallons of soy sauce at a time. Rice was a staple for the Hee family, and they ate it every day, even with holiday dinners. Chinese pastries were not available locally and were one of George Hee's special treats to bring home. The Hee children would sometimes take them to school for lunch. To this day, the Hee children chuckle remembering when their sister, Loretta, drove their father, George Hee, to San Francisco. Because it was very difficult to find a parking space nearby, he would make her drive around and around the block until he came out with the supplies. To this day, the Hee family makes quarterly trips to San Francisco to buy supplies, even though they can now purchase some basic supplies locally. These trips are now for special items not available in Mendocino and because they feel at home in Chinatown. George Hee and his son Wesley are shown here fishing on Big River. Fishing with his sons was a favorite activity of George Hee's. (Courtesy Hee family collection.)

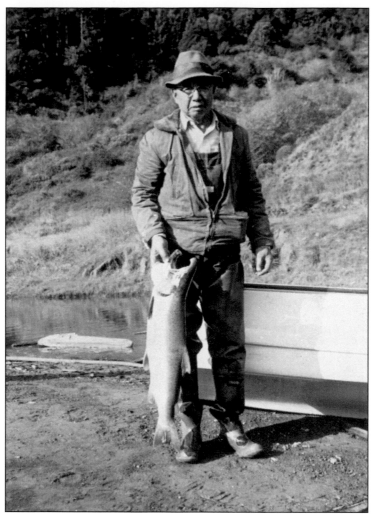

Because their father was older, the author and her siblings did not have a typical childhood. They spent every weekend with their parents hunting or fishing to provide for family dinners. Their parents made the outings adventures so it did not seem like a chore, and at the same time, the children were taught survival skills. George Hee taught all his sons to fish and hunt, skills that have paid off for his sons. They hunted together until he was no longer physically able to join in, then he would drive them to the area to watch and wait. George Hee loved fishing and baseball. He played on a baseball team and was a devoted Giants fan until the day he died. When the children were young, George Hee had several hunting dogs, but no one was allowed to play with them, because they were working dogs. The Hees grew their own vegetables and ate what was in season. Life was simple, and because of the isolation of the coast, the family learned to live off the land in Mendocino. In the summer, they caught surf fish and smoked what they could not eat. They picked huckleberries, salmon berries, blackberries, and apples east of Mendocino in orchards that were no longer attended to. The berries grew wild all around the area. In the fall, the family would fish for salmon out of Big River, and in the latter part of the fall they would go to the river to crab. The Hee family ate Dungeness crab on the beach or took them home to cook. They also dug for mud clams along the mud flats of the river and used them to make chowder. This is one of the many salmon that the author's father, George Hee, caught on Big River. (Courtesy Hee family collection.)

George Hee's family is pictured here before Dewey Hee went off to college in 1969. From left to right are (first row) Wayne and the first grandchild, Carrie; (second row) Mervin; Lorraine; Loretta; and Raymond; (third row) Dewey; George; George's wife, Martha; Loretta's husband, Dan; and Wesley. (Courtesy Hee family collection.)

George Hee is pictured here with his family behind his mother's property on Main Street in 1969 before Dewey Hee left for college. From left to right are (first row) George Hee's wife, Martha; George; his only daughters, Lorraine and Loretta; Loretta and Dan's daughter, Carrie; George's son, Wayne; and the family dog, Tina; (second row) George's son Dewey; his son Raymond; his son Wesley; Loretta's husband, Dan; and Mervin, Loretta and Dan's son. (Courtesy Hee family collection.)

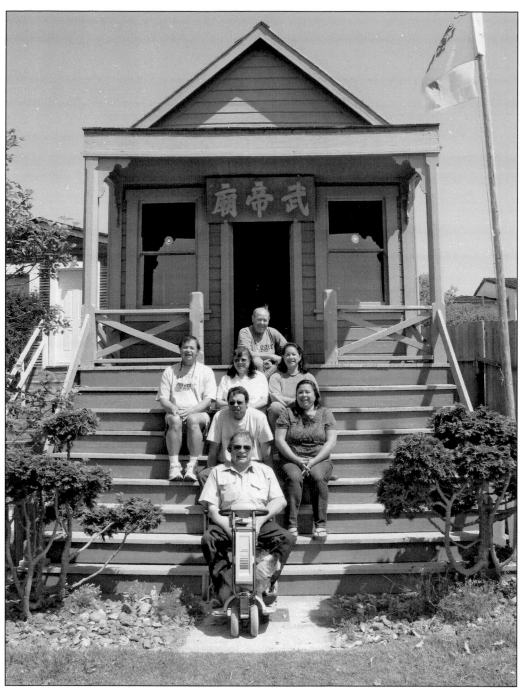

These are George Hee's children on the steps of the temple of Kwan Tai in Mendocino on July 5, 2008. These are the only descendants still alive from the previous photographs taken in 1969. Pictured from left to right are (first row) Dewey; (second row) Wesley and Carrie; (third row) Mervin, Lorraine, and Loretta; (fourth row) Dan. Raymond, the eldest, and Wayne, the youngest, are both deceased. (Courtesy Jeff Kan Lee.)

It is fitting to close with a 2008 shot of the Hee family's fourth generation, who continue to carry out their father's promise to save and protect the temple of Kwan Tai forever. This promise can be found in a 1976 article from *Mendocino County Remembered, Vol. 1,* where George stated, "It's up to the children to see what they're going to do with the Joss House. I left it to them. When my mother was alive, I told her I'd keep it as long as I'm alive and it's up to the children to do it now." The fourth generation has kept the promise, and they are grooming the fifth generation to continue to save and protect the temple. The Lee-Hee family is shown here sitting on the temple of Kwan Tai's steps, celebrating their great-grandparent's legacy. In the front is Dewey; in the second row, from left to right, are Mervin, Wesley, and Loretta; and Lorraine is in the back. (Courtesy Jeff Kan Lee.)

This is what Mendocino's Main Street looks like today from across the Mendocino Bay. (Photograph by Jeff Kan Lee.)

BIBLIOGRAPHY

Bear, Dorothy. *The Chinese of the Mendocino Coast.* Mendocino: Mendocino Historical Research, Inc., 1990.

Chinn, Thomas, ed. *A History of the Chinese in California: A Syllabus.* San Francisco: Chinese Historical Society of America, 1969.

Dispatch-Democrat. January 11, 1915.

Holmes, Alice. *Mills of Mendocino County.* Ukiah: Mendocino Historical Society, 1996.

Lee, Jonathan H. X. *The Temple of Kwan Tai.* Mendocino: Temple Kwan Tai, Inc., 2004.

Levene, Bruce. *Mendocino County Remembered: An Oral History.* Vol. 1. Ukiah: Mendocino Historical Society, 1976.

McCunn, Ruthanne Lum. *An Illustrated History of the Chinese in America.* San Francisco: Design Enterprise of San Francisco, 1979.

Parks, Annette White. *Ghawala Li "Water Coming Down Place," A History of Gualala, Mendocino County, California.* Ukiah: FreshCut Press, 1980.

Wie Min She Labor Committee. *Chinese Working People in America.* San Francisco: United Front Press, 1974.

Discover Thousands of Local History Books Featuring Millions of Vintage Images

Arcadia Publishing, the leading local history publisher in the United States, is committed to making history accessible and meaningful through publishing books that celebrate and preserve the heritage of America's people and places.

Find more books like this at
www.arcadiapublishing.com

Search for your hometown history, your old stomping grounds, and even your favorite sports team.

Consistent with our mission to preserve history on a local level, this book was printed in South Carolina on American-made paper and manufactured entirely in the United States. Products carrying the accredited Forest Stewardship Council (FSC) label are printed on 100 percent FSC-certified paper.

MADE IN THE USA